THE COLORFUL APOCALYPSE

THE COLORFUL APOCALYPSE

JOURNEYS IN OUTSIDER ART

GREG BOTTOMS

THE UNIVERSITY OF CHICAGO PRESS
Chicago and London

The University of Chicago Press, Chicago 60637
The University of Chicago Press, Ltd., London
© 2007 by Greg Bottoms
All rights reserved. Published 2007.
Paperback edition 2015
Printed in the United States of America

24 23 22 21 20 19 18 17 16 15 2 3 4 5 6

ISBN-13: 978-0-226-06685-1 (cloth)
ISBN-13: 978-0-226-06687-5 (paper)
ISBN-13: 978-0-226-06688-2 (e-book)
10.7208/chicago/9780226066882.001.0001

Library of Congress Cataloging-in-Publication Data

Bottoms, Greg.
 The colorful apocalypse : journeys in outsider art / Greg Bottoms.
 p. cm.
 ISBN-13: 978-0-226-06685-1 (cloth : alk. paper)
 ISBN-10: 0-226-06685-1 (cloth : alk. paper)
 ISBN-13: 978-0-226-06687-5 (pbk. : alk. paper)
 ISBN-10: 0-226-06687-8 (pbk. : alk. paper)
 1. Art, American—20th century. 2. Outsider art—United States.
 3. Spirituality in art. I. Title.
 N6512.7.B68 2007
 709.73—dc22

 2006036203

The view of man as a symbolizing, conceptualizing, meaning-seeking animal, which has become increasingly popular both in the social sciences and in philosophy over the past several years, opens up a whole new approach not only to the analysis of religion as such, but to the understanding of the relations between religion and values. The drive to make sense out of experience, to give it form and order, is evidently as real and as pressing as the more familiar biological needs. And, this being so, it seems unnecessary to continue to interpret symbolic activities—religion, art, ideology—as nothing but thinly disguised expressions of something other than what they seem to be: attempts to provide orientation for an organism which cannot live in a world it is unable to understand.

CLIFFORD GEERTZ

I'm hoping people will give me some access—talk with me and help me figure out what's going on around here.

WILLIAM CARLOS WILLIAMS in conversation with Robert Coles

CONTENTS

PROLOGUE

The Reverend Howard Finster was twenty feet tall, suspended in darkness. He wore a paint-spotted flannel shirt, a tattered blazer, and dirty work pants. He sat in his favorite chair, an old hand-tooled rocker, crossed his legs, and swung one of his clay-caked boots in the air like a scythe.

I was sixteen, watching Tony Gayton's 1987 documentary *Athens, Georgia, Inside/Out*, which my friends and I had driven thirty miles to see at the Naro, an art-house theater in Norfolk, Virginia. We went because part of the film was about R.E.M., whose first three recordings, *Chronic Town*, *Murmur*, and *Reckoning*, we considered masterpieces, a jangling mix of the New York punk ethos—the Velvet Underground, the New York Dolls, Television—and lo-fi Southern garage pop.

As teenagers, as self-proclaimed *hip* teenagers, we imagined a bohemian existence, dodging the arbitrary rules of square suburban life, was the straightest way toward freedom. R.E.M. and the twangy do-it-yourself alternative music and art scene in Athens, Georgia, represented this lifestyle most acutely in our minds. None of us knew then that *Esquire* magazine had featured Finster and his four-acre Christian "visionary" art environment

Paradise Garden in an article entitled "Backyards" in 1975, portraying him, as is often the case in writing about outsider artists, as a loveable nutcase, a gaudy eccentric. Or that he'd been a guest on the *Tonight Show* in 1983, where he told Johnny Carson and the audience that he made art for the same reason one might scratch an itch—"cause he had a feelin' to." Or that R.E.M. had filmed the video for "Radio-Free Europe," their first college-radio hit, on his property. Or that Finster had collaborated with Michael Stipe on the cover art for the album *Reckoning*, and later with David Byrne and the Talking Heads for their album *Little Creatures*, which sold five million copies and won *Rolling Stone*'s Album Cover of the Year award in 1985. And we didn't know he was already the toast of the lively Athens/Atlanta art scene, with the High Museum and the University of Georgia's art department as steadfast champions of his work, with Phyllis Kind, an art-world tastemaker and an early American proponent of "self-taught art," representing his paintings at her gallery in New York and later at the Braunstein Gallery in San Francisco.

In my imperfect recollection of the film (I haven't watched it again so as not to destroy this memory with a lesser reality), Finster played his favorite five-string "banjer." Every time he hit a high note with his index finger, he would then hit the top note, the low note, with his thumb—the call and response of old-time music: high and low, yin and yang, heaven and earth, God and man. It was a sound, he liked to say, a *holy* sound, that he could "put on your brain cell and you'd never forget it."

Then he began to preach in a slow, nasally Alabama drawl. I don't recall exactly what he said—he was so big, so bright, so overwhelming in his jocularity—but I'd guess now that he preached as he always did, as he had done every day since he was a boy, of God and peace and love, of lost souls, of salvation for the sinner if only he would know the Lord.

What I do remember clearly, what sticks with me in photographic stop-time even as I write this, was the calm of his wrinkled face, sunlight glinting in his bifocals, his ash-gray hair combed back over the top of his head and shaggier, wilder, around his ears and collar. And that something about him—his expression, stooped posture, voice, age, fragility, I don't know— moved me, as sentimental as I know that sounds.

Finster wasn't a total stranger to my friends or to me. Our own genealogies sank back into the world he inhabited, the poor, God-haunted South. Our grandparents and parents, *my* grandparents and parents, had worked and saved to eke their way from the Southern lower classes (Finster's world) into mainstream, middle- and working-class life. They made it from the tobacco farms of North Carolina to the industrial jobs of southeastern Virginia. They became construction workers, welders, computer technicians, secretaries, bus drivers; they became taxpayers, mortgage holders, Methodist and Episcopalian churchgoers (Pentecostalism, Holiness Church, and Church of God were "white trash" once you made it to the suburbs and started worrying about what the neighbors might think). They became—this is what I mean—upstanding American citizens.

Standing safely in this mainstream, middle- and working-class life, my friends and I skateboarded, wore surfer fashions, and drank quarts of cheap beer behind the grocery store Dumpster. We felt bored, stifled. I can still see us, among the cigarette butts and oil stains, casual and contrived, with our shaved heads or spiky dos, fitting in among our cohort by imagining all the ways we didn't fit in, couldn't fit in, wouldn't *want* to fit in the larger, soul-oppressing world.

Like Howard Finster, like our musical tastes, we wanted to be bigger than life, bigger than tragedy, Romantic and Apocalyptic, the seeds of our destruction layered through our slang and gestures—a bunch of teens huddled together and ranting with

our new-found lifestyles and bruised bodies and well-thought-out haircuts and worn-out clothes in the craziness of growing up in America. And I, for one, was starting to think—and talk about in a stream of slow-mo garble while high on North Carolina homegrown—that moments of startling beauty, of distilled sense, of heartbreak that were somehow understandable existed rarely in life but *sometimes* in art, in a great poem, painting, novel, or song. Life itself was frameless and plotless, and often seemed hopeless; but the act of art could be a salve, an elixir, a temporary balm glazed over the chaos—a way of symbolically holding the past still in the light of present consciousness and reworking it until, at least for a fleeting moment, it *meant* something.

On October 22, 2001, fourteen years after my first impression of Finster up on that art-house screen, I was driving over and through the foothills of the Blue Ridge Mountains to Sweet Briar College, where I was teaching creative writing to undergraduates. From the public radio station came a report about Finster's death. It was maybe two minutes long, nothing spectacular: commemorative, mildly elegiac, much editorial use of his distinctive, sound-bite friendly voice.

I pulled over to the side of the road and wrote the following in a notebook:

movie

death

 loss

poverty

 memory

 insanity

 creativity

faith

 THE PAST

It was raining and the traffic threw water over my silence. The abstract words on the page made little sense, but I stared at them for several minutes. While the car idled on the gravel shoulder, I thought about how I'd been collecting notes on the famous Reverend Howard Finster and two other representative— elderly, artistically "naïve"—Christian visionary artists: William Thomas Thompson, a handicapped ex-millionaire who saw the horsemen of the Apocalypse at a church service in Hawaii and then spent three years painting a three-hundred-foot version of the book of Revelation; and Norbert Kox, an ex-member of the Outlaw biker gang, whose father, sitting in an old La-Z-Boy, morphed into a crucified Jesus just before Norbert dispensed with most of his possessions and moved into the Wisconsin wilderness where he wrote nine hundred pages of Christian prophecy and began to paint "apocalyptic visual parables" and portraits of the "false Christ."

By the time I heard of Finster's passing, ideas of outsider art and institutional art (as Arthur Danto famously called it), conformity and nonconformity, all the gray area between madness and Christian ecstasy (this especially), had become, for reasons that will soon be evident, my central preoccupations, my tape-loop of concerns.

Rain *plink-plinked* on the windshield. I was restless, looking for something to do. *Drifting.* I decided, right then, I was going to Georgia.

That's how these travels began: absurdly, one might say, or at least haphazardly; with a tinny radio voice, a notebook, and a sudden, unwieldy uprush of memories, the themes of my personal past—illness, breakdown, the myths and symbols of Christianity—flooding through me again like a great, gray wave.

I set for myself, that day in the car, a few simple tasks: to travel and look and listen and record. I didn't know what I would find.

THE FIRST NOTEBOOK

Visions from Paradise

During moments of triumph [in painting] one has the sensation of having mastered the landscape according to its own rules and simultaneously of having been liberated from the hegemony of all rules. Some might describe the position as god-like. But there is a common experience which it resembles: the experience of every child who imagines that he is able to fly.

JOHN BERGER

... people do not live their biographies.

ELIZABETH HARDWICK

1

"Missionary Mary had a vision of my father," says Beverly Finster. She is the youngest of Howard Finster's five children and the manager of Paradise Gardens, his outsider art environment in Pennville, Georgia, which he spent several decades constructing and reconstructing, plastering with biblical quotes, sermons, and apocalyptic warnings.

We're driving in my minivan. Morning sun glints off the damp asphalt, turns puddles alongside the highway into moving pools of sky-colored light.

"A vision?" I ask.

"Yeah," she says. "She saw him last night in a dream."

Beverly is in her mid-forties, a feisty, business-minded blond woman who looks quite a bit like her father, with her small eyes and downward-sloping nose. She incorporated Finster Folk Art, Inc., as it is currently known, and added an *s* to Paradise Garden, so it is now Paradise Gardens, a "park" that charges admission ($5 for adults; $3 for seniors and children; free for children under five). She is a painter herself, and recently finished one of her father's final works, undoubtedly dropping its monetary value exponentially. She also runs her own business, Finster Framing, in a town just over the Alabama border.

She seems to think I'm a newspaper journalist, will produce a short article, publicity for the struggling Gardens, though I told her I was an English professor, interested in making notes for a book about Christian fundamentalism and the idea of visionary outsider art. One of the first things she asked me when I arrived, with an air of impatience, if not outright surliness about the whole enterprise of the interview, was, "Okay, what are your questions? Gotsomequestions? Askmeyourquestions." I can't blame her, though. People have been badgering her about her father since she was a teenager.

Aimed south on U.S. 27, we're off to Rome, Georgia, on a warm, sunny Saturday to rent a sprayer to repaint the bottom floor of the World's Folk Art Church, Finster's biggest and most ambitious functional sculpture. With the grant-writing help of Victor Faccinto, an art professor at Wake Forest University, Finster used a National Endowment for the Arts grant in the early '80s to purchase an old church abutting his land from a pastor named Billy Wright. Shortly after this, following visions of "beautiful mansions with big domes" that "made a negative in [his] brain," he added several floors and a steeple of wood and sheet metal and bits of tin and broken glass and remade the building into not so much a work of art as a monument to his waking dreams, an assortment of refuse and warped planking transformed into something of obsessive detail and intricacy. The World's Folk Art Church (sometimes called "the chapel") will be the centerpiece for the festivities at Paradise Gardens tomorrow, December 2, 2001, Howard Finster's posthumous eighty-fifth birthday and memorial.

Missionary Mary's vision, Beverly continues, was of Finster in the sky, in the bright light of heaven. He had a "pretty smile" on his face and was wearing a black suit, which, Beverly says, was the one he was buried in.

"Missionary Mary could *not* have known about that suit," she says, excited. "When I told her, I says, 'Mary,'"—long pause for effect—"'*that's* the suit he went to see God in.' And she says, 'Oh, you're kidding me! Beverly, you've got to be *kidding* me!' And I says, 'No, Mary, I ain't kidding.'"

Beverly smiles and huffs through her nose, looking at me, as if to let the supernatural weight of her comments settle down around us.

The timeworn southern spine of the Appalachians is visible to our west. Hum of tires. Clear sky, barren trees. Brown and gold hills all around us like a bunched rug.

"So Mary Proctor was a friend?" I ask.

"Oh yeah. Do you know about her? She's a great painter herself. You ought to go meet her. You'd definitely learn something about what a Christian is. Yes, you sure would. She paints old doors, an artist down in Florida who got real close with my father. She wanted to come tomorrow but can't make it. I guess you could say she's a lady prophetess, just a real powerful Christian woman.

"Mary's mother put her in a ditch when she was born, and her grandmother said, 'I know you've had that baby, now you go get her.' The mother brought her to the grandmother, and the grandmother raised her. Several years ago the grandmother was burnt up in her house with other family members. At that point, Missionary Mary started doing her painting and her artwork, and a lot of it is based on the teachings of her grandmother. She's had lots of shows. She's gotten herself right famous."

"That's horrible," I say.

"The shows?"

"I mean the fire. The fire is horrible."

"Yeah. Bad." Beverly stares out into the bright, speeding distance. "Lot of people died in that house."

Beverly speaks like this often—dramatizing exchanges, conversation veering toward the tragic and metaphysical. Earlier she told me, without a trace of irony or even figurative thinking, that she was waiting for her father to return from heaven and give her guidance on how to run Paradise Gardens (fiduciary, business-plan sort of guidance). Evidently money is a big issue; I get the feeling that finances are dire, but Beverly doesn't want to talk about it, so I don't push her. It's clear, though, that she actually expects her father to be sitting in a chair in a room one day, when the time is right. He'll smile, and then get down to business with the advice.

We look out the windows for Eddie Rents, a big, red warehouse that should be coming up on the left.

When I spoke to Beverly a few days ago by phone, she said I could come down and "get a story," but that she would be busy and I might have to pitch in. Now I'm chauffeuring her around northwest Georgia, looking for a paint sprayer, which is harder to find than one might imagine, even in this rural place.

As we ride along the empty highway, land rising and falling under us like swells in a deep, calm sea, I think of why I've really come—my idea, my project. I've read about the money squabbles between Finster's five children, which the author and outsider-art scholar Tom Patterson described in *Raw Vision*, a by-turn fascinating, informative, and amateurish art journal devoted to "outsider art, art brut, and folk art," as "not unlike those that often surround lottery winners." I have of course read criticism of Finster's "commercialization," of how he became a dupe of the art world, and of his later work as being hackneyed (which strikes me as neither here nor there, because how do you judge something by the conventional critical assessments of art when it exists, first, as a stream-of-consciousness ministry / service announcement for your soul?). I've heard that the Gardens are sinking into ever-faster rot (true). But I—how can

possibly say this?—I'm here for something harder to define, for a better understanding of the intentions of the man I saw up on that art-house screen fourteen years ago, a man whose strange biography and body of work have been celebrated and mythologized, denigrated and criticized, written about and presented in such a way as to mystify what, I think, might otherwise be obvious and clear, simple and simply human. I've read the biographies and autobiography, and now I want to hear stories from those who knew Finster, want to understand, get inside, as much as that is possible, the mentality, the fiery Christian *psychology*, that produced, by best estimates, more than forty-six thousand works of art.

Or so I'm thinking as the white dashes arrow by.

The art critic Peter Schjeldahl, who writes as well as anyone about art, dismissed Finster's work in the *Village Voice* in 1982, said he could "see no proper use for it." And certainly, if one comes at the reverend's art—or most outsider art, for that matter—armed with a Greenbergian formalist's eye, an aesthete's sense that a painting is first and foremost a *painting*, one may indeed dismiss it quickly. But outsider art is not fuelled by aesthetic concerns, at least not primarily. It is more often fuelled by passion, troubled psychology, extreme ideology, faith, despair, and the desperate need to be heard and seen that comes with cultural marginalization and mental unease. Schjeldahl, in his review, went on to say that it was clear that Finster's mind was "a prison." Maybe here is one question at the heart of my endeavor, which, admittedly, I will probably not be able to answer. If your mind is a prison—and one could argue, as Schjeldahl suggested, that *every* mind is a prison—can artistic expression . . . can religion . . . can religious or spiritual artistic expression be a key to get you out of your suffering?

Beverly clears her throat, sits quietly—a stranger to me, and me to her.

Missionary Mary Proctor's Southern gothic tale of woe is no more severe than Finster's, who lost several of his siblings as a child, including a sister to rabies from a dog bite and an older, mentally retarded brother who died an agonizing death after catching on fire in the family home. In fact, Finster's first vision, documented and recounted until it now approaches the level of parable among his fans and followers, occurred at the time of his sister's death when he was only three years old. She rose up above a "mater patch" on their family farm in Valley Head, Alabama, and then proceeded to glow and walk up concrete steps toward heaven.

Later Finster began having visions and dreams that he could fly. He had new powers—of metaphysical sight and flight—and suddenly death and sadness, which were everywhere, had no dominion over him. He was magic, of God, untouchable.

I know about visions and how the mind can become, in Schjeldahl's words, "a prison." I grew up with a schizophrenic brother who had a penchant for heavy metal, karate, snakes and spiders, scaring women in pizza parlors, and mediocre pencil drawings of fantastic creatures; a brother who turned to Christian fundamentalist thinking and made similar "visionary" claims—about God in a window, about voices under his bed, about an angel in his room and receiving direct messages from scripture; a brother who then attempted suicide a couple of times, lived homeless in central Florida, admitted to a homosexual rape and murder that he did not commit, and finally tried to murder my mother, father, and younger brother in an act of bungled arson. And my experiences with my mentally ill brother—which spawned this curiosity about "ecstasy" and "insanity," which have indeed forced me to "renounce the convenience of terminal truths," as Foucault put it—are the origin of my interest in this type of art from the societal margins, the history of which I began to study

almost by accident while writing a short book about the tragedy and spiritual dimensions of my brother's illness.

Books in this field led to other books, and soon I had files and folders, notes and fragments, around the house. In every account of a true outsider, I saw, I think, my brother and myself, the schizophrenic and the writer. There it was: the existential moment of loss, the "dark night of the soul," and the struggle, through expression, to get back from the abyss, out of the prison, to live comfortably inside your own skin and circumstances. The schizophrenic—trust me on this one—gets stuck in dark fantasy, shunned from the world by the ill workings of his own mind; the so-called healthy artist will often have to turn away from the world, live in fantasy and the artifice holding that fantasy up. And the same desperation that drives people to art drives people to criminal acts, I sometimes think. They can both be beyond the bounds of the rational.

The only "crazy" people I've heard about (Finster possibly included here) who have found a tolerable way to get through life without swallowing endless bottles of tranquilizers and psychotropic drugs have done so by devoting themselves to some form of creative expression that addresses their aches and longings. They get to a place where the strictures of mainstream society, of civilization as it is currently formed, weigh less heavily upon them.

Looking over all that has been produced about Finster—the numerous books, magazine and newspaper articles, documentaries, sound recordings, CD-ROMs, and video tapes—one could argue, as with most outsider artists, that the interest in his work over the last thirty years stemmed from his stranger-than-fiction biography and personal eccentricities—the postmodern obsession with oddity and the Other at the heart of some outsider art collection—which obviously places him beyond

psychological and social norms, whatever those might be, and which possibly began in the aftermath of trauma.

I think of all the famous stories: the paint smudge on his finger in 1976 commanding him to paint "sacred art"; the fifteen-foot giant at his gate; his working day and night, driven by visions of Jesus and Elvis and Hank Williams and George Washington, drinking pots and pots of coffee, barely napping, and never taking his shoes off "for months"; or the one about him shouting for everyone's attention at an art show in Georgia and then preaching of how all of man's inventions were underground, placed there by God, and we just dug them up (a notion reminiscent of aboriginal "dreaming" and songlines, only with Ford trucks, Fender guitars, and Elvis's sequined pants instead of rocks and rivers); or how he said—and he said things like this *every day*— "Howard Finster is from God. Howard Finster has a gift from God. Like I tell everyone, I do not have ideas, I have visions." Sounds like something my brother might have said before being asked to leave the school parking lot or the church social.

Beverly and I continue on in our awkward silence, and a pang of sadness moves through me as I envision, rightly or wrongly, a roomful of art browsers and collectors—people, in my mind, who can discuss surrealism, Guy Debord and Situationist Internationale, the heyday of CBGB's in the late '70s and early '80s, and Harry Smith's folk archives with equal ease—eating expensive cheese and sipping fine French wine, at once celebrating and patronizing an old man who had a fifth-grade education and misspelled many of the biblical messages in his paintings.

As we approach the Eddie Rents warehouse on the left, I finally almost generate a question. I ask Beverly if she thinks her father's creativity, like that of Missionary Mary's, came from pain, was sort of, you know ... I'm not finding the right words.

"Well," she says, "yeah, he did have lots of loss. There was thirteen children in his family, and a lot of them died before they

ever got grown. Only a very few of them ever got grown. I guess everybody's life influences what they do. I reckon everyone's filled to here"—hand held horizontal at the top of her head— "with reasons."

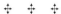

As we head back to Paradise Gardens with the sprayer on a faux-Mexican blanket in the back of my minivan (I left a baby seat on the Gardens' porch so I could fold the seats down), Beverly tells me to take a left off of U.S. 27, onto a barely two-lane road winding past a few small houses and long stretches of scrub-pine and cedar woods. Light blinks through the high trees, spreading a shadow mosaic along the pavement. We begin driving (I will later think) into one of her dreams.

"Junk collector—that's what they called him when I was kid," Beverly says. "A boy once said I made roach cakes because we didn't have no money. He was just being ugly, though. Some people's just ugly in their heart. Everybody thought my father was crazy, that we were probably all crazy, just poor old crazy bumpkins, you know, but he didn't care. He was busy working and preaching. He showed everybody, though. God sent him here for just a short time to do His work. He got himself real famous. He never did a thing wrong in my eyes."

"I'd go to the dump and collect all kinds of beautiful things," Finster once said. "When people's loved ones died, they would clean up a house. I would go there and get the stuff they throwed away—old trunks, boxes with jewelry in it, all kind of stuff."

Beverly tells me that she thinks her father was "exploited." I don't understand. I'm not sure whether she is referring to money or the media or the small network of outsider art collectors and museums, but I know that it sometimes hurt her when

filmmakers and journalists, art students and hippies and intellectuals, buyers and browsers and gawkers, used to come around and ogle the old man, America's most famous outsider artist, like a sideshow attraction or a comic performer.

Some people dug what he was saying, no doubt, but others simply came for the novelty, the strangeness. They thought him a fool, a Christian weirdo, some kind of backwoods jester. But he was her father, and she loved him more than anything, and she wants to protect him—from me, from whomever—even, or perhaps especially, in death. Beverly understands that with the celebration of his work and life also came the stigma of his difference, his "deviance," his "outsider" status. She wouldn't put it like this—in the sometimes arid language of the professoriate, I suppose—but she definitely gets it just the same.

The road curves back to Silver Hill Baptist Church, a small, white building atop a hill of brown grass, surrounded by the arthritic trees of late fall. This was the last church Finster officially pastored.

A large, brown pickup truck with a winch mounted on the back is parked in the grass, near a half dozen or so graves. Several workers stand around. They straighten up as we approach, look our way as gravel crunches under the van's tires.

"Oh," Beverly says.

I park. We get out.

And there it is—Finster's grave, the earth grassless in the size and shape of a coffin.

A tall, bearded man in a NASCAR hat and brown overalls is brushing off the tombstone with a dry, fine paintbrush. They've just finished putting it in the ground.

Beverly greets the workmen—she seems to know them, talks to one about a child, school, something—then walks around, looking at the large stone.

The hill is steep, and from my vantage below on the road she looks, momentarily, as if she is leaning down toward her father's grave to keep her balance.

I walk up the hill.

One of the men drinks from a 7-Eleven Big Gulp cup. Another puts a large plug of tobacco into his cheek. Another sits squeakily on the tailgate of the truck.

I feel awkward, intrusive, stuck inside a moment belonging to someone else. I never met the man. I can't properly define for Beverly—I'm still working it out for myself—what I'm doing here, hanging around, asking questions, tape recording, and now I'm standing near his fresh grave. The remaining two workers by the headstone back away out of respect, go to the truck with the others. I step back, too. Beverly stands there alone: a child over the dirt-covered coffin of her father.

Finster's tombstone is a long, horizontal rectangle spread across the width of two graves, one reserved for Beverly's mother, Pauline, who still lives in the Finster home in nearby Summerville. There are a couple of two-foot high marble vases, one on each side of the stone. On the left of the stone it says, *william howard dec. 2, 1916–oct. 22, 2001.*

The message in the middle reads, *precious lord take my hand,* and two hands, one from heaven and one from earth, meet. At the base of the grave a plaque states, simply, *husband and father.*

I write all of this in my notebook and draw a sketch of the church, the hill, the tombstone, a stick figure representing Beverly leaning forward in an exaggerated way. I think Finster himself would have chosen for an epitaph *visionary artist* or *God's messenger* or *stranger from another world.* His family, or at least Beverly, saw him otherwise. It occurs to me for the first time, as I look over the jottings in my notebook, that my father died on October 21, eight years ago, and I suddenly remember, standing

in slanted sunlight, that my schizophrenic brother, on October 22, Finster's death day, made a request through corrections officials who called me directly to leave the psychiatric wing of a prison to attend my father's funeral, even though less than a year before he had attempted to murder him. My brother loved my father, missed him so much, was so, so sorry, *please let me come home.* I was having late-night negotiations with a mental breakdown at the time. Had the phone in my hand turned into a snake it wouldn't have surprised me.

Maybe this is my dream, then, or our dreams have gotten tangled.

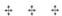

Back on the road to Paradise Gardens, which needs a lot of work before the birthday celebration tomorrow, Beverly calls her mother on a small, silver cell phone to tell her how beautiful the stone is, which no one in the family has seen.

She says, "Okay unhuh yeah course right. I know."

Long break in her talking as she listens.

"Love you, too," she says. Then she clicks off the phone.

There is a pause—travel, the engine—and then she starts weeping. It comes quietly at first, as I look straight ahead, then in wet, ragged gasps.

I want to reach down and turn off the recorder. But I fear that will make the moment more awkward than it already is.

2

Here is a white, sheet-metal effigy of Finster. It's about life-size, maybe slightly smaller. Surrounding it are three large, colorful arrangements of fresh flowers, the longest stems about waist-high. Metal Finster sits in a rusted, fold-out chair, holding a worn and out-of-use banjo. I begin to make a quick drawing in my notebook.

A rough sketch of a face wearing large glasses is drawn on what is meant to be the head, which is shaped like a shallow snare drum turned on its side, or a deep tambourine. On one leg is written "Romans"; on the other leg, vertically, is "10:9: That if thou shalt confess with thy mouth the Lord Jesus, and shalt believe in thine heart that God hath raised him from the dead, thou shalt be saved." The whole thing appears to be made out of house gutters and is set up in the southeast corner of Paradise Gardens, under the splintered, white front eave of the World's Folk Art Church, as if preparing to play a gospel show.

From behind me: "Like it?"

I turn. "Did you make this?" I point.

"Yeah, that's mine all right. I made it in my shop in Kentucky and brought it down here for this." We shake hands. "I'm Mike,"

he says, in a deep Southern accent. "Mike Laster. C. M. Laster, a Christian folk artist."

Mike is in his mid-thirties, about five-nine, medium-built. He has a brown goatee and Neil Young sideburns and bright, friendly eyes. He's wearing a train conductor's hat and denim overalls. He smiles a lot, has been walking around grinning and hugging people, but not in a way that seems unctuous.

I look at Mike's expression for a moment, to gauge whether he is being ironic—do people refer to themselves as "Christian folk artist"? Evidently, yes.

"Were you a friend of the Reverend Finster's?" I ask.

"More than a friend. Howard saved my life, man. He saved me and my wife's lives."

Mike met Finster in the mid-1990s while first making his own art. Mike and his wife had been alcoholic and "pretty heavy into drugs" and had just recently gotten sober, with some occasional giving in to temptations and backsliding. Things back home in Kentucky were a disaster. With no money, no prospects, nothing, they went around with a little Fisher-Price audio recorder taping conversations and occasionally making paintings and assemblages that they sometimes tried to sell but no one, it seemed, wanted to buy. Then Mike's brother died of a prescription drug overdose.

"We were low," Mike says. "I was heartbroken. Nothing was going right. And when my brother died—man, it was like I wasn't going to make it, you know. He was young. Twenty-seven. His whole life was wasted, just gone, and for what? Then Kelly—Kelly's my wife—and I came down here. We'd heard a lot about Finster because we had friends in Athens." The Lasters used to go to rock shows in Athens when they "still partied," and Mike and I have a moment in which we commune around mention of '80s alternative rock music—Flat-Jet Duo, Chickasaw Mud Puppies, Love Tractor, and of course early R.E.M.

"We spent a whole day with Howard out here in the Gardens," Mike continues, "and he just told me to pray on it, to talk to God about my brother. He said if I prayed hard enough and I believed, everything would turn out in the end. He said the answer is Jesus."

So Mike went home to Kentucky and started reading the Bible and praying and working on his art, which was now overtly message-driven and Christian in its subject matter, often about the ills of drug and alcohol abuse, the temptation of Satan. He and his wife were "born again," with the help of Finster. It wasn't an overnight thing—it required work, he says—but soon they were living their life for the Lord Jesus Christ.

Mike tells me that his brother, when he had been healthy and sober, ran their family's business, a company that makes the type of small metal sheds you see in places like Lowe's and Home Depot (where Mike got the scrap material to make the Finster effigy). Out of work, not wanting to work for his family but instead to be an evangelist and Christian folk artist, Mike took a job cleaning some old buildings in his hometown of Crofton—taking out the trash, repainting the insides. Grimy work, but he was broke, and it was good for clearing the head. One day at work he was listening to the radio, "to that Blue's Traveler song; what's that called? I forget what it's called, the harmonica one," and thinking about his dead brother, with whom he was angry for killing himself, and who he loved and missed so much that some days he thought he might fall over from the weight his grief.

"I had just finished cleaning out a building," he says, facing me squarely now, speaking clearly for the recorder. "It was spotless, and I was sweating real bad, you know. Wiping my face. Then I started crying. I mean I was falling to pieces in that little building that smelled of sawdust and trash. I was thinking, 'Why did he do it, why did he have to go and kill himself like that?' Then I

thought of what Howard told me—to pray on it, to talk to God, to try to understand that there is a greater and better life to come, to let God lead me to the answers that I need. I closed my eyes, and I said, 'God, just let me know that his soul is okay. Just let me know that he ain't tormented no more the way he was down here. Please, God. Please.' And when I opened my eyes—you ain't going to believe this, but it's true, it's the absolute truth—there was a *pencil* on the floor right in front of me. I mean, I had just cleaned out that whole room, and now here was this *pencil*—one pencil, right in the middle of an otherwise spotless floor. I picked it up"—he looks at me silently for a second, holding an imaginary pencil, and I get the feeling that he has told this story many times before, that it is a testimony—"and it was one of my family's business pencils. Something went through me. My brother was real big on putting the name Laster on everything—cups, shirts, pens, hats, pencils. You probably think I'm nuts, but I know that was a sign from the Lord above about my brother's soul, and after that I was okay. After that, slowly, things started looking up. It was a turning point in my life. Seek and ye shall find. It was like the weight had come off of me, you know. I don't know if you've ever lost a brother, man," he says, "but it's tough. It's a hard thing to grow up with someone like that and lose them."

In the years after this incident, Mike and his wife made regular visits down to see Finster. Eventually they began organizing art shows with him for children, sometimes going out to housing projects. They also began to sell their paintings, many from the small gallery at Paradise Gardens, but also at outsider art fairs and festivals (I will later see one of Mike's sculptures at the American Visionary Art Museum in Baltimore and one of his paintings, of Elvis introducing the "real King" Jesus, in the book for the show *Coming Home: Self-Taught Artists, the Bible, and the American South*). The Lasters became close friends—"family"—with Beverly and Howard.

Finster encouraged them, prayed with them, and fed them. And they in turn told Finster, whose health had been waning for a number of years, who was both diabetic (thus he always carried around an old, tan suitcase full of candy to share) and on blood-thinning medication, that they would help him get the Gardens back in order so it could have a future—perhaps, the Lasters and Beverly still hope, as a Georgia state monument.

I spend most of the rest of the day talking with Mike and his wife Kelly, a small woman with long, red hair and a pretty face that looks older than it probably is, etched with hard living and loss. Seeing her, I think of a man very dear to me, almost like a father, and how beautiful his younger sister was before she became a heroin addict and aged twenty years in the span of five, losing some of her teeth and hair and shape. Kelly is twenty-five or she is forty. I can't tell.

The Lasters refer to themselves as "psychedelic Baptists," born-again believers who don't quite fit in at most churches, and they would still look right at home at an Athens, Georgia, rock show or block party. In fact, I imagine we look—Mike with his sideburns and overalls, Kelly in her old rag wool and worn jeans, me in a quilted flannel, mussed hair, beard, and arty glasses—like an upstart musical act up from the University of Georgia.

I tell them that religion is something, from one angle or another, I am often interested in writing about. I tell them it fascinates me, always has. I tell them it has been central to my life.

When they want to bow their heads and pray with me, though, I decline, as much as I appreciate the welcoming gesture, and understand that they are offering me what they believe to be their most valuable possession—their belief. When the talk turns, later, to conversion experiences, finding new life in the Lord, I clam up, elongate my lips in a smile and nod, listening.

We walk around the Gardens, which have been emptied of many of Finster's larger, more well-known works (several of which are on permanent display at the High Museum in Atlanta), over bits of broken green glass and tile that he painstakingly embedded in the concrete. Thin shafts of emerald and white reflected light flicker ahead of us, moving at exactly our speed.

We look at the famous Mirrored House, the original bike shop where Finster received his legendary commission to paint in the form of that talking face on his thumb.

I read the biblical messages everywhere, on everything, telling me to repent, to turn away from corruption, to save myself before the end. The only pieces that haven't been sold off by his five children are the permanent buildings or things impossible to move. One generation away from the Southern lower-class, I know that need and survival and the possibility of financial comfort trump, any day, ideas of "artistic integrity," which really are, in the words of my grandmother, "fancy notions," and in the words of one of my Marxist academic friends, "bourgeois constructs," formulated by those with money and leisure time on their hands. This place is to bourgeois mainstream culture or elite artistic culture what my brother's religious outbursts were to my parents' quiet, suburban Methodism.

Later, walking on springy ply boards through wood tunnels over "brooks" that are really ditches, Mike tells me of Finster's ability to see into people. For instance, the Lasters once brought a friend who hadn't worked in years and "lived off the government" down to visit the Gardens and meet Finster. As soon as she sat down, Finster said, "Well, I reckon a person needs to work for living." And there was another friend—again, one Finster had never met—who had a drug problem. Finster's first

sentence to her: "I reckon a person on cocaine would do just about any old thing."

Then they tell me about all the Finster angels, one of his trademark, cartoonish design motifs often used in the borders and backgrounds of his paintings and assemblages, filling up the entire sky as they drove along the highway one snowy, winter dusk. At first I think they are talking about a painting—I'm not following the story. Then I realize they mean actual angels filling up the sky, moving between clouds, drifting and glowing beyond a foreground of wet, heavy snowflakes.

They also tell me of the UFO, how they believe the red lights they saw one night over eastern Alabama were in fact the soul of Mike's recently deceased grandfather zipping through the sky. All the language here is magic. No amount of questioning can get them to turn their thinking away from the supernatural, so, well, why bother?

Wanting to contribute to the conversation, I mention how earlier in the day Beverly Finster and I drove up to Finster's grave just as the workers had finished putting in the tombstone, and how I felt strange seeing it before his family.

"That's a miracle," Mike says, startling me by touching my arm. His eyes are wide, his expression serious. "You're in Howard Finster country, man. You were supposed to see that because the Lord wants you to understand something."

3

At the Express Inn in Trion, with books about madness and re-
ligion spread across the stiff bedspread of my king-size bed, I
read through the DSM-IV, the 1994 diagnostic manual for psy-
chological disorders I've brought along with the vaguest sense
that it might be pertinent research.

Everything can be pathologized. Tell me what's wrong with
you and I'll tell you what you have. For instance, I discover
Finster's type of sleeplessness can be found in the medical de-
scription of both mania and post-traumatic stress disorder. His
behavior throughout his life, and particularly in the last twenty-
five years, could be diagnosed as obsessive-compulsive. His hal-
lucinations, I find, could place him with my brother neatly under
the umbrella phrase "disorders of schizophrenia" (disorganized,
catatonia, paranoid, undifferentiated).

In another book, however, E. Fuller Torrey's widely used
Surviving Schizophrenia, which I reluctantly read in my early
twenties (too cool and smart, then, for anything resembling a
self-help book) and found very helpful in trying to understand
my brother's illness, I discover that the psychiatrist, writer, and
concentration-camp survivor Dr. Silvano Arieti attempted to
distinguish the hallucinations of his mental patients suffering

from schizophrenia from those of the deeply religious throughout history (Moses, Jesus, Paul, John of Patmos, Mohammed, Joan of Arc). He wrote the following (vague but well-meaning) criteria:

(A) Religious hallucinations are usually visual, while those in schizophrenia are predominantly auditory.

(B) Religious hallucinations usually involve benevolent guides or advisers who issue orders to the person.

(C) Religious hallucinations are usually pleasant.

Nowadays, of course, any hallucination would be considered a symptom and not an alternative state of being. In the age of biochemical psychiatric care, all but the poor and marginalized (not a small number in the United States, but almost entirely voiceless) and back-roads charismatics get treated for such things. Thus you won't find a lot of middle-class, insurance-card-carrying "visionary" artists or, for that matter, artist inmates and patients like Adolf Wölfli, Martin Ramirez, or Johann Hauser, because upon arrival in a contemporary institution you get a syringe-full of thought and emotion deadener. One's impulse to make images to communicate needs, longings, hopes, fears, and what might otherwise be incommunicable—which is to say the essence of true outsider art—is not part of the managed care system.

I close the book and toss it on the bed. I look around—at the purple carpet, the flowered bedspread: hotel life, the ostensibly clean veneer laid over untold wallowings and conversations, untold *histories*, has always made me uneasy. I imagine a schizophrenic sitting on this bed and hearing every conversation that ever took place in this room, imagine—remember—the way my brother would laugh and cry apropos of who knows; how he wanted to say, had something to say, couldn't say; how when

he was highly medicated it was like someone had extracted his soul.

I pick up W. H. Auden's *The Prolific and the Devourer*, which he wrote to reconcile his thinking on the artist (Blake's prolific) and the politician (the devourer). He was, famously, in the midst of a spiritual crisis, a conversion from communist bisexual to born-again Christian trying-not-be-a-bisexual when he wrote it. I threw the book in my bag almost thoughtlessly because I hadn't read it yet after years of owning a copy, and I was recently intrigued by a scene in Anatole Broyard's *Kafka Was the Rage* where Broyard's girlfriend Sheri smashes into Auden, spilling the poet's armful of books across a New York City sidewalk. After today, after being inundated with the language of the supernatural, Auden seems perfect, because what he sought was to *rationalize* and *philosophize* religion.

The Prolific and the Devourer is a strange book, but the best kind, I think at the moment. It is a diary of sorts, one voice speaking out of the dark—insular, almost "outsider" in how it exudes a sense of privacy, how it seems to exist without much thought about audience.

After about half an hour, I read

> Everything that happens is a witness to the truth: the special value of miracles is that they reveal the imperfection of man's knowledge, and stimulate him to search further: They induce humility and curiosity. A miracle has not borne its full fruit until it is understood, that is, until it has ceased to be a miracle and can be repeated at will.

Here is an intellectual take on Christianity, on superstition, not at all in keeping with the unquestioning vibe of Finster, the hard-core Christian enclaves of the American South, and this place. There is a whiff of the phenomenological here, God as

Levinas's Other, some infinite yet unknowable force we might look for but will never find. The critic Dave Hickey once wrote that people who believe in magic "exist outside the discourse and beyond contemporary culture." True enough if, like me, you grew up Methodist in suburbia and now write essays, stories, and criticism for magazines and journals and teach in an English department. Less true, maybe flatly false, if you live in the rural South, in the glowing heart of Christian evangelicalism, light years from literary culture and academia, even secular suburbia.

Here's Auden again:

Our grounds for Faith: the unhappiness of man.
Our grounds for Scepticism: the same.

I flop back on the bed. "Do you not feel the breath of empty space?" wrote Nietzsche in *The Gay Science*. When things go wrong, when Nietzsche's "breath" moves over your skin, reminds you that you are but a blip in the existence of the world, destined from birth to vanish with all the things and people you love, to mulch the land with no more magic than the rotting carcass of a bird, it's nice to imagine a little comfort, a God out there in the void, one who will maybe explain one day what all the death and sorrow was about.

In the mid-1990s, in the years after my brother went to prison for setting my family's suburban Virginia home on fire, I spent a lot of time and energy thinking about societal norms, aberrant behaviors, trauma, and religiosity, particularly when the latter became indistinguishable from contemporary definitions of insanity. I became intrigued, to put it mildly, by the particulars of some emblematic visionary art biographies—whether religious

or psychotic or, as R. D. Laing put it, beyond the "sharp distinctions between sanity and insanity," ecstasy and psychological breakdown. There is of course a narrative pattern to the tale of the modern artist-naïf: profound despair, the breakdown / visionary experience, then an obsessive devotion to some "mission" to save the world through the dissemination of their all-important message, which can become ego-healing and, in its way, life-affirming.

As a graduate student at the University of Virginia, ten years after seeing Finster at the Naro Theatre, I came across a book published in 1922 entitled, in the practical and utilitarian fashion of psychology and psychiatry, *Artistry of the Mentally Ill (Bildnerei der Geisteskranken)*. It is, in the field of outsider art, a famous book, but I didn't know that then. The psychiatrist Hans Prinzhorn, an adherent to the high modernist aesthetic of his moment, and also an accomplished poet, musician, and art historian, wrote the monograph while at the Heidelberg Psychiatric Clinic in Germany, just one year after Walter Morgenthaler, a psychiatrist in Bern, Switzerland, wrote a monograph on the art of Adolf Wölfli, who, along with Henry Darger and Finster, would become one of the few widely known outsider artists. During a time of radically changing attitudes regarding madness, the time of Jung and Freud, Kafka and Dada, as well as other avant-garde artistic and intellectual movements stressing the importance of the subconscious as both a symbolic repository and a well-spring, Dr. Prinzhorn amassed a collection of nearly five thousand drawings, paintings, and objects created between 1890 and 1920 by about three-hundred and fifty patients, many of whom had suffered breakdowns and claimed to see and hear things that then found their way into their creations. Some of these artists / patients / inmates were eventually "exterminated" by the Nazis as "degenerates" after their works were shown, with banal cruelty, alongside "proper" nationalistic art during

Hitler's infamous traveling Degenerate Art exhibition in the late 1930s.

Part of Prinzhorn's book focused on—and this is what pulled me in that day, sitting there in a dusty cavern of books—ten "schizophrenic artists." One of these artists / patients, Peter Meyer (1872–1930), also known as Peter Moog, who produced detailed religious works in watercolor, believed he had been chosen, like my brother, like Finster, and a huge number of other outsider artists all over the world, as a servant of God. He felt God as a "power vibrating in the hand," directing him.

Artistry of the Mentally Ill led me to other work in this area—into worlds almost always brutal and sad—by psychiatrists such as W. A. F. Browne, Gaston Ferdiere, and Cesare Lombroso, and then on to French painter Jean Dubuffet's famous anticultural works, *Asphyxiating Culture and Other Writings* and *Jean Dubuffet: Towards an Alternative Reality*, in which the essay "Art Brut in Preference to the Cultural Arts" is collected. Dubuffet was given a copy of Prinzhorn's book in 1923 while living in Paris. During a time of "revolt against [French] culture," when Dubuffet was influenced by artists and thinkers such as Max Jacob, Blaise Cendrars, Marcel Duchamp, and André Breton, he championed the mad men of the world as the only true artists not selling out to the empty expressions of mainstream, elitist culture. "The works," he wrote, "that make up the very substance of culture—books, paintings, monuments—must first be regarded as resulting from a misleading choice made by the cultured people of the time, and next, as providing us with altered thoughts—thoughts, moreover, that are only those very particular thoughts of the cultured people, belonging to a miniscule caste."

Dubuffet's ideas were reminiscent of many other antibourgeois artistic and political movements—romanticism, transcendentalism, the French *symbolistes*, surrealism (which he was

closely aligned with), Situationist Internationale, the beats, hippies, punk rock, poststructuralist literary and cultural theory, and so on—in that they called for a turning away from the accepted (and, in his mind, false and lifeless) products and ideologies of culture. The works of artists indoctrinated within their culture could only be so radical and original. To subvert accepted artistic forms—even to the extremes of Leautremont, Beckett, Brecht, Woolf, and Picasso—was to acknowledge the power of those forms. To create *against* rather than make new. Existing within the organizing principles of culture was, to Dubuffet, a way of being trapped inside the grand, modernist metanarrative of *tradition*—a rat in a maze always walking by the same walls, always looking for the same narrow shaft of light when one could be looking for the sun itself.

Art brut, as Dubuffet called it, offered new expression in forms so strange and new it was like walking around inside of someone else's dreams and secret longings (in many cases, almost literally). These artists from the societal periphery—many of whom at this point had been or were in either asylums or jails—had no concept of "rules."

The angsty postadolescent in me who thought Elvis Costello and Johnny Rotten geniuses—or the equivalent term for those who might spit on the word "genius"—agreed with some of Dubuffet's thinking, found it, in fact, *cool.* But the part of me still trying to shake growing up around acute mental illness—the part of me that knew actual people struggling on the margins—couldn't help but feel Dubuffet was himself bound within the coarse thinking of his cultural moment (as we all are) in the sense that he had little concept of true, unwanted marginalization, deep religious faith found among the mind's ruins and desperation, or the suffering of madness (whatever it *is*, it exists). His thinking was all about art and its relationship to culture. He was criticizing, theorizing, and this necessarily took place at

many removes from the human lives of the artists. Madness, in this abstracted equation, equaled freedom. I always ruffle a bit at how abstraction, or pure theory, obliterates the individual in an effort to trace and explicate cultural shifts and causations, to show, as Octavio Paz once suggested, that there is nothing left to believe in but criticism.

From Dubuffet I encountered—in that same library, at that same table—Leo Navratil's *Schizophrenia and Art* and Roger Cardinal's seminal *Outsider Art.* Cardinal both came up with perhaps the best term for this art by untrained, unschooled artists from the cultural edges and also sought to define what, exactly, it is—not an easy task and a matter of ongoing debate. Building on Dubuffet's thinking, Michel Thévoz, former curator of Dubuffet's Collection de l'Art Brut in Lausanne, Switzerland, wrote the following:

> "Art Brut," or "outsider art," consists of works produced by people who for various reasons have not been culturally indoctrinated or socially conditioned. They are all kinds of dwellers on the fringes of society. Working outside fine art "systems" (schools, galleries, museums and so on), these people have produced, from the depths of their own personalities and for themselves and no one else, works of outstanding originality in concept, subject and techniques. They are works [that] owe nothing to tradition or fashion . . . "Art brut" artists . . . make up their own techniques, often with new means and materials, and they create their works for their own use, as a kind of private theatre. They choose subjects which are often enigmatic and they do not care about the good opinion of others, even keeping their work secret.

Though Thévoz, as Dubuffet had done, comes close to portraying madness as too much of a neat thing for my taste, a Blakean sloughing off of civilization's spiritual chains, a

hip-beat-punk "derangement of the senses," as Rimbaud put it, his is as useful and succinct a definition as any. And to his credit, he has pointed out the often "fragile constitution" of outsider and visionary artists, and how pushing them toward the art world, the museum world (a "dead and even hostile place," according to anthropologist Michael Taussig), can be "one of the vicious traps of the society of the spectacle."

From another book on my bed, Colin Rhodes's recent *Outsider Art: Spontaneous Alternatives*, I read that John MacGregor, one of the best writers and thinkers on the subject of outsider art, has written, "I believe that the creation of art is intimately linked to the spirit of revolt. Insanity represents a refusal to adopt a view of reality that is imposed by custom. Art consists in constructing or inventing a mirror in which all of the universe is reflected. An artist is a man who creates a parallel universe, who doesn't want an imposed universe inflicted on him. He wants to do it himself. That is a definition of insanity. The insane are people who push creativity further than professional artists, who believe in it totally."

Even this, though, comes close to mystifying. R. D. Laing once wrote that one could "know . . . just about everything that can be known about the psychopathology of schizophrenia or of schizophrenia as a disease without being able to understand one single schizophrenic." I believe something similar could be said about visionary outsider art: one could read every book and article available on the subject—there are many—and not understand a single artist.

I watch about an hour of religious programming, sort of sociologically. A black man in a purple suit, his head shower-wet from sweat, cures a woman of diabetes while people in the

congregation shout. Lots of life lessons about the ills of phi-
landering, the importance of taking care of your kids, "stick-
ing around" and owning your "responsibilities." Amens are the
punctuation: period, question mark, exclamation point, maybe
even colon. One way to get to God, or more quickly anyway,
has to do with Visa and MasterCard. Usual stuff, I suppose.

I click off the lights. I toss and turn. The air is dry and stale.
There is a *tick tick tick* in the heater and if I move the polyester
spread makes a sound like my dog scratching: *ffft ffft ffft*. What
you get for forty-nine bucks a night. Plus a few Georgia cock-
roaches.

At five in the morning a woman in the parking lot starts shout-
ing for Bill and Geneva. "Beeeeeuuuulll! Guneeeeeevaaa!" over
and over. "Missy's in the hospital, she's real bad sick! Beeeeeeeu-
uuullllll! Guneeeeeevaaaa! Missy's in the hospital, she's real bad
sick! Beeeeeeeuuuuuulllll! Guneeeeeevaaaa!"

I get up, peel back the thick curtain, and look out the window.
The shouting woman is seventy easy, frail-looking and on her
knees, as if in prayer. An obese white teenager in a tilted, side-
ways baseball hat and a red Puma tracksuit is gesturing for her
to stand. "Come on," he seems to be saying. "Come on."

When the short commotion is over and the boy gets her up and
heading toward the front office, I walk away from the parking
lot lights and back into the darkness, the curtain dropping shut
behind me.

Twenty minutes later my phone rings. I fumble for it, knock-
ing it off the hook and onto the table with a sharp, plastic *crack*.

When I get it to my ear, I recognize the voice: The old woman
from the parking lot. She asks me if I am her son.

"No," I say.

"Are you from Virginia?"

"Yes."

"Is your van in the parking lot?"

"Yes."

"But you're not my son?"

"No, ma'am. Sorry."

"My daughter might die, you know," she says, her voice dropping, as if to show her disappointment in me.

"I'm sorry to hear that."

After she hangs up, I hold the receiver in my hand and wonder, for just a second, if I'm asleep, if this is the scene where I float out over the parking lot and fail to save someone's life.

4

Early the next morning, on the way back to Paradise Gardens, I notice the Hays State Prison; its long blacktop drive begins near my hotel. The prison borders the neighborhood where Paradise Gardens is.

Like this: go to the end of any of the streets, past the blue and green and gray clapboard houses, past the clotheslines and rusted, metal swing sets and broken driveways resembling aerial shots of continental plates and fault lines, past the brown grass and big American cars (some wheel-less and up on cinderblocks), and you will see the maximum-security prison, massive and angled and gray, with fencing around it like a row of shark's teeth, like a dare.

In July of 1996, a "black-clad riot squad," as reported by the *Christian Science Monitor*, performed a basic contraband raid at Hays and twenty-four inmates were injured, some severely. This later became national news when the American Civil Liberties Union got involved, pointing out that Georgia prisons were particularly inhumane and that Hays State, the fence of which you could hit with a good, hard Frisbee throw from the front yard of Paradise Gardens, was an example of how bad things could be. That a prison exists so close to this neighborhood,

virtually *in* this neighborhood, perhaps alleviates some of the need for me to further describe this place, to dwell in the kind of particulars of which I'm usually fond. I'll put it simply: it is the kind of place—filled with the uneducated, the on-the-brink of poor, the struggling—where state officials finally decide to put a prison. Everyone says not here. Eventually you make your way down to the powerless, then ignore their wishes. I imagine it employs a good number of town's folk, improves, at least a little—in political parlance—the "local economy."

The wild color of the Gardens juxtaposed against the dim, forbidding gray of these neighborhoods and this prison is either all wrong or perfect; I'm not sure. I want a cleaner narrative line; I like to have a sense of an ending as I move along, and I want things to reveal their connections to other things, to show unity, to make sense. Life, though, works more like a postmodern novel—lots of dead-ends, oblique, cryptic suggestions, and inconclusiveness. Maybe life actually works more like a *bad* novel, now that I think of it—hard to follow, requiring way too much charity from the reader.

I park near the prison's outer perimeter, a couple of streets north of Paradise Gardens, to drink a weak cup of gas-station coffee with an iridescent rainbow of oil floating on its surface, like river water behind a tug. I look through my notes, which are getting very strange, as if *I* am having a religious conversion or a mental breakdown:

Jesus saves but only through sanctification
UFO lights carry souls
Everything goes back to God
Dead people appearing in dreams = cosmic purpose

An art collector I met yesterday, a guy who told me about his abusive father and the "magic of raw expression," about the

light in children's faces—"Have you seen it, Greg, have you seen it?"—and about Finster making a poster for the 1996 Atlanta Olympics (which he spelled "olempics," thus averting a copyright infringement issue), is rollerblading alongside the razorwire fencing, wearing a teal top and tight, white shorts in the abnormally warm weather. The wheels of his skates are neon yellow. He has on kneepads and wrist guards and gold, gleaming jewelry. His thin, blond hair stands up in the wind like a fin. He is quite graceful—this effeminate man zooming past the razor wire, past the place where the black-clad riot squad beat several prisoners unconscious—and I want to say that is a beautiful moment, one worthy of a photograph. But from my van I can see a guard coming out of the first gatehouse to ask him what the hell he thinks he's doing.

5

My neck is stiff, my eyelids heavy, their insides sandpapery when I blink.

Disoriented, I look for the documentarians, David and Susan Fetcho, fiftyish intellectuals from Oakland, California. I met them a couple of days ago. Actually, when *did* I meet them? Should I be writing down dates, times? Anyway, they're here getting footage for a film about outsider artists. They have, I believe, the last taped interview of Finster.

A lot of people are around this morning, the morning of the party—maybe twenty-five or thirty—all busily pulling weeds, carrying paint brushes and cans, walking around with banjos and guitars and microphones and amplifiers. I need to start with the Fetchos. Hokey religious programming seeped into my dreams last night. That woman screaming and the call about her dying daughter have me feeling jagged, foggy. I like Mike and Kelly Laster. They are genuinely kind people, a strange mix of hippie and Southern Holy Roller, and I believe they would give me their last dollar if they thought I needed it more than they did. But they're devoted followers of Finster, speak of him the way I imagine the disciples spoke of Christ, and I need a more objective view of this.

The documentarians are aging hippies. They have not, I feel sure, hallucinated or communicated with the dead or seen angels and flying lights. At least not lately, and never without the help of chemicals.

As I walk through the gate to the Gardens, Kelly Laster greets me. "Good morning," she says, smiling.

She has on the same bright-red sweater from yesterday. She comes close, stands less than a foot from me, and toe-to-toe, staring into my eyes as she speaks: "Myrtice West is in the gallery. She'd like to talk to you. I really think it's important that you interview her for what you're writing."

Inside, West stands in the sun-filled gallery, wearing a maroon Sunday dress and glasses, the lenses of which are the circumference of adult fists. Her dark-gray hair looks unwashed, but there has clearly been an attempt to style it with large curls and pull it back. Wrinkles spread horizontally across her large forehead and vertically down to the bridge of her nose. Her cheeks are flushed red, and deep creases carve along either side of her mouth, her chin almost a separate piece of her face, like a puppet's.

In her seventies, West is one of the more celebrated outsider artists of the South. She has a book, *Wonders to Behold: The Visionary Art of Myrtice West*, which begins with a thoughtful essay on Christian apocalyptic imagery and tradition by Medieval art scholar and curator of the "Coming Home" show Carol Crown, devoted to her series of thirteen intricate paintings based on her dreams and a literal reading of images and metaphors from the book of Revelation. She lives with her husband, Wallace, whom she married at seventeen, in Centre, Alabama, twenty miles from Pennville, Georgia, and Paradise Gardens. She was a good friend of Finster's.

We shake hands. Her hand is small, wrinkled; her grip is calloused. Her face twitches slightly, like a TV that needs adjusting.

"Son, have you accepted Jesus as your Lord and Savior?" she begins in a deep Alabama accent, swallowing some sounds and accentuating others, so a phrase like the "Lord Jesus" becomes "lowered jaisus."

I smile. West, in her bluntness, her unedited and fast talking, immediately reminds me of my grandmother—my father's mother—who was institutionalized twice for depression and alcoholism, but, remarkably, seemed happy and at peace late in her life.

"That's what Howard would have asked you," West continues. "He would have made sure you was right with the Lord, and then he'd get to talking and playing his banjo. You can't come down here like no big shot on a story now. You got to have your heart open and your eyes open and your mind open." She points at my face. "You got two eyes to see with and two nostrils to breathe with and two ears to hear with. You've got senses up in your head. Old Howard. You know what he did right—preached and preached, right up to the day he left us. But he's not dead. He went home. He's where he's supposed to be. I wished I was dead many times. Just gone." She slices her arms through the air, palms down—gone. "But I guess God put me here and he means to keep me. I had cancer, you know. Right here." She points to her abdomen. "I couldn't have no babies for a long time. I lost two babies because my insides was all wrong. I looked at James, and He said look at Job. Then I look at Job"—she holds her hands open, as if reading a book—"and I see me. I see my life, the life of Job. I'm in the Bible. Howard and me was chosen."

I ask her when she met Finster. What year? For my notebook. The facts, you know. I'm trying to write a book.

"I met him at a flea market long about many years ago. He had him some paintings and I had me some paintings and we traded."

I make a note. *West met Finster—flea market—traded paintings—year?*

"You're not going to believe this," West says, "but I went to a Holiness Church in 1977. It was twenty miles thataway." She points with her left hand at a wall. "I reckon I walked there. I got up and spoke in them there tongues. Now you can't speak in no tongues in front of that kind of congregation. These was Southern Missionary Baptists, see, and you do that in front of them they liable to put you on out of their church. My hair was going up in the air." She runs her fingers through her hair. "Like this here. People can't understand this. My hair was straight up in the air, like electrocuted. Well when I come to myself I looked at them people and there I was with their Bible open to the book of Revelation and the story of the seven churches and I said, 'I'm sorry people but I don't know where I'm at. I don't know why I'm here.' I had just then started painting, you know. A woman jumped up then in that there church and she says to everybody, 'She's Christian. But ya'll don't know this woman. She'll put anything in the Bible right out there on a canvas! She paints Jesus and everything!' They thought I'd gone crazy, course." She furrows her brow, squints. "Just crazy."

She takes my hand, an abrupt and tender gesture, as we walk up a short staircase in the small front gallery, through almost liquid sunlight, to look at some of her new work. The paintings are bright, childlike, one-dimensional scenes of the Fall of Man, what critics and scholars in this field might refer to as "vernacular" in composition and "visionary" in impulse. In the background are snowcapped mountains; in the sky, American flags. In the foreground are serpents and what looks like blood. (As with Finster, her "best" work—her most unusual and inspired and passionate and obsessively detailed work—was done before her engagement with the art world, when she created

out of her own desperate psychological need rather than with a mind to sell art.)

Though untrained, West has a remarkable intuitive skill with color and composition. The contents of her paintings—in this gallery, and later in other galleries, and especially in the book devoted to her and the Revelation murals—remind me of old folk ballads: violent, death-dealing and death-haunted, demanding of your attention.

I look at her again, her wrinkled face and hands, her Sunday dress. She is an elderly woman from the fundamentalist South heading to church, and later to the local Old Country Buffet with her husband and Bible group, where her husband will eat so much he must unbutton his pants, where she will pray over steaming succotash and talk with friends about gardening. That she paints these works seems hard to believe.

I let the tape recorder roll. She starts telling me the story of her life. There is no concession to time or logic—no coherent narrative with beginning, middle, and end. She lets out a torrent of impassioned words; anecdote flowing into anecdote, her face more pained and contorted with each new thought, each word. She has a practiced autobiographical spiel, though no concerns about linearity—it is montage, pastiche—and she speaks it to me guilelessly, as if she has always known me, or, perhaps, as if I am a wall or a mirror, not even there.

When she was a teenager—in the '40s on a farm in northeast Alabama—she watched a neighbor's baby girl some afternoons. It was a beautiful baby, she says. She loved that baby, and then one day the baby got sick with diphtheria, "which was killing off everyone," and the baby started acting strangely and not moving. "Got real tired and white. Have you ever seen a baby just alaying there?" She wanted to save the baby; of course she did. She wouldn't have ever let that baby die if she could have helped

it, but it did, it died, and as she tells the story she jumps through time and seems to connect that dead baby to her two miscarriages, and that beautiful baby that was not her baby becomes, in the tone of her talking, her baby, one of the ones inside her, one of the ones she lost.

"So I went back into depression and back into my drawing. I always liked to draw."

She disappeared for long hours, and she didn't remember things—but when she came back, she couldn't do anything except lie down on the hard, cold floor and read her Bible and draw, just draw and draw and color. Mostly she drew pictures of Christ.

There are other stories, about her house burning down, about her brothers missing in World War II, about the sound of planes over Norfolk, Virginia, about how she had to walk outside at night when she was a teenager so her mother wouldn't hear her "crying and carrying on," about a vision after surgery, about her drug-addicted grandson, whom she raised and who, the Lasters told me, robbed her house once when she went to an art fair.

I can't make out a time sequence. Forty years in long, unpunctuated paragraphs. Glossolalia.

Finally, she tells me the story of her daughter, Martha Jane, born September 13, 1956, a miracle baby. Later, at home, in *Wonders to Behold*, I'll see a picture of Martha Jane on the day of her wedding, June 3, 1972, standing childlike and smiling and strikingly beautiful in white among her bridal party of seven other girls, each dressed differently in green or lavender or blue or pink. In the photo they stand in a summer yard, in thick, green grass, with a pond behind them. The day is sunny. You look at the photograph, a moment yanked out of the flow of time, and every one of those kids—and they are *kids*, children—lives forever.

Martha Jane married a hot-tempered, abusive man named James Brett Barnett when she was fifteen. Her life, West tells me, was black eyes and bruises and cracked bones. In 1974, when

Martha Jane and Brett's son Bram was born, Brett began acting cruelly toward the infant and his wife, beating them often; West, on several occasions, threatened legal action. Later that year, Brett joined the Air Force. In 1977, he was stationed in Japan. Anxious and nearing breakdown—this would have been the time of the Holiness Church incident, I think—West began to study the Bible for the better part of each day and she painted her first work of religious art, *The Ascension*. In 1978, Martha Jane, Bram, then four, and Kara, an infant daughter, joined Brett in Japan. West began to paint the first of the Revelation series paintings. Meanwhile, shortly after her daughter and grandchildren's arrival in Japan, Brett beat Martha Jane so badly that she ended up in the hospital. After this incident, West heard her then-four-year-old grandson's voice in the doorway of her Alabama home: "Granny, don't close the door on me," he said. "Granny, don't close the door on me." He was in Japan, of course, but she kept hearing him. She took this as a sign from God.

West finally received word from someone in the military about her daughter. Martha Jane had a concussion, and the children were fine—with their father. West then spent most of the next two days in the woods and in the barn, praying and drawing pictures of Christ and sketching scenes from Revelation.

"It worried Wallace to death," she says. "He thought, what's that old crazy thing doing down there in the barn? Shouldn't she be on the phone? But I couldn't take it. I wanted me a picture of Jesus for my baby. I wanted Jesus to go over there to Japan and protect my babies."

I believe painting for West is like praying, a kind of concentrated ritual meant to show total devotion and thus bring about positive change.

Eight years later, on October 25, 1986, while the couple was separated and living near Birmingham, Brett shot Martha Jane five times, twice near the eyes and three times in the top of the

head, pointing the gun down into her body, one of the bullets coming out of her neck. He did this at his mother's house on his daughter's ninth birthday while both of his children were in the hallway waiting for the party. Before the shooting, West says, he gave his daughter one of her old Teddy Bears for a present, told her *it was her present and not to complain, to just take it and shut up*, he'd be back in a minute. In 1987, Barnett was sentenced to life in an Alabama prison and is still calling the incident a suicide, despite the fact that lawyers and judges have numerous times pointed out that suicide with five fatal gunshot wounds in the eyes and the top of the head is impossible. He currently, according to West, considers himself a minister.

Maybe it's from lack of sleep, or my inability to be objective or stoically professional as a journalist, if that's even what I'm pretending to be; or maybe it's because talking to Myrtice West makes me think of my brother and the desperation and violence attendant to his sad, sad life; or maybe I'm just thinking about all the stupidity and petty cruelty and mean violence I've witnessed; I don't know; but I start tearing up toward the end of the interview when she tells me the part about her grandson, who she raised after her daughter's murder, the one who has robbed her house. I can't stop myself. He was twelve back then and refused to believe his mother was dead, even though he was *there* when it happened. West had to take him to see his mother's grave to convince him. He ran around the graveyard screaming, saying that his mom couldn't be dead, that it was his fault, that he should have done something, should have stopped his huge, savage father, stopped the bullets, saved her. *That* kind of grief, Bram's kind, can unhinge you forever, make you only a deformed wraith of your former self. It is easy to ruin a life—my life, your life: it can take only a little well-placed destruction.

I'm not embarrassed about wiping my eyes, though, as the tiny wheels of the recorder spin, because West is emotional, too. It's

like crying in front of a priest or a doctor or a psychotherapist—just part of the heavy discourse.

"Jesus said that it has all already been written," West says. "Sometimes God moves the bars back and lets Satan get ahold of you. God had the light four days before he made the sun. He made man the last thing. And man ruined it for this world. Satan got let lose. It's all ruined now." She clasps her hands together.

I began this more than two-hour interview by asking West about Howard Finster. Finally, as if she suddenly remembers my original question, she repeats that Finster isn't dead. He's home. In heaven. Just like Martha Jane.

"If you want to know the difference between me and Howard," West says, "it's that Howard was always trying to help the sinner. He wanted to forgive people and help people. There was people around here all the time, laughing and carrying on, lots of them sinners. Howard wanted people to find God and love each other and be happy. I reckon that was the Southern Baptist in him."

"So what about you," I ask. I click off the tape recorder. "What's your message?"

"My message." She looks out the front window; a huge flock of black birds sits in a tall, naked tree above a small, gray house with dead leaves in the yard. "My message is that this is the end. I saw Jesus in that Holiness Church. His hands was braided together, held up over his head, like this here, and in between his fingers, in the light, was a message about the Jews and the end of the world."

6

Later in the day, an hour or so before the old-time music and the birthday memorial, I find David Fetcho and ask him if he would mind showing me the Finster section of the documentary he's working on. We go to Paradise Cottage, a small rental room on the grounds (sixty dollars a night, with a life-size cardboard Elvis for company). He puts the tape in the VCR.

Before we watch the interview, I ask David, a serious and articulate man with slightly graying hair and small, fashionable glasses, to tell me about his project.

"For our documentary," he says, "we're interviewing aging outsider artists—not necessarily just in the South, but obviously a lot of them, because of the foundational religiosity of the region, live in the South. We want to show their passion and their commitment and the way that they've found to speak with both authenticity and power from the margins of society. All these folks lead very peripheral lives in terms of the normative social structures. They are driven by something outside of commercial success or acceptance. Both Myrtice West and Howard would have done what they've done even if no one ever noticed. And in a way—and this is what is so fascinating to me—they don't really care about the long-term viability of their art. Perfection

of craft and vocation are not at all what drives them. What they care about is getting up every day and engaging with the materials and speaking through these materials about their lives and what they mean in a grander scheme."

"The materials are mostly a conduit for the message," I say.

He nods.

I remember Kelly Laster telling me of a fight she had with an art critic who said Finster's later work was inferior to the early work. She became angry, she told me, and said to the critic that true art was an eighty-four-year-old man getting up every day and picking up a brush because he had something he desperately needed to say—for this, with something of the countercultural "we are all artists" to it, is how she and her husband define art.

I mention Freud's thing about adult art having a sense of audience.

"Sure," he says. "And there is obviously childlike wonder in all of this, in the best way."

I make some notes.

"I think Howard had a fire in him," David says, kneeling on the red carpet now, fiddling with the VCR remote.

"Do you think he was ill?" I say, more bluntly than intended. "I guess I mean *clinically*. Like diagnosable. Do you think one trauma too many, some chemical misfiring, whatever, pushed him over the edge, and that's what all this was about—and it just *happened* to sync up with media interest and make him a minor celebrity for a time?"

"Well," he says, and I can tell my question has caught him a little off guard. "How should I put this? I think that Howard, in very stark terms, and very early, was confronted with the absolute fragility of life, the ease with which we die and leave the world and are, by most, completely forgotten. Howard was very much trying to tell us about the preciousness of life. He took tragedy,

the worst things, and worked it into a basic understanding of what life is and what we mean in that grander narrative. The resolution to our predicament, for Howard, was in the Gospel. He was a Christian first and foremost, a preacher. He looked into the Bible. He looked into tradition. He looked into his own life." He sighs, thinks for a second, thumb on the remote. "It's sort of like suddenly in life you realize that all of your worst suspicions about the world are confirmed. And maybe that's the day you really become an adult, or a sadder person, I don't know. You know what I mean, right?"

"Sure."

"Right. But for *Howard*, and for a lot of these devout outsider artists, they don't go near adulthood. Forget rationality. Forget the material world. There is a better suspicion, a more tolerable suspicion, one that ends in eternal life and grants forgiveness and resolution and a hope beyond all this, beyond the grave. That's the one that Howard hung his hat on, the one he lived his life by and the one theme that ran through every piece of art he ever made."

"I find it fascinating," I say. "People all over the world—all of them disenfranchised in some way—waking up one day when all hope is finally lost and deciding to make monuments for God, or their dead mother, or some voice they've been hearing, or whatever. Even forgetting all the painting and sculpture and drawing and assemblage, and thinking only about huge outsider environments like this place—by Simon Rodia, Ferdinand Cheval, Tressa Prisbrey, Makiki, Eddie Martin, Leonard Knight, Vollis Simpson, and the list goes on and on, as you know—it's just mind blowing. It seems very sad, frankly."

Or it's against sadness, he suggests.

"Or maybe against disappearance," I think out loud. "Against invisibility. And who's to say who's delusional in all this? Lots

of stuff that's accepted out-of-hand in our culture is profoundly messed up."

"Right!" David says. "And that's part of what's great about some of the most powerful outsider stuff: it's different and beautiful *as art*, but it's a new perspective, and makes you question widely accepted perspectives that shouldn't be accepted at all."

He stands up and looks at the remote for a moment out of the bottom of his glasses. He pushes some buttons, says, "This thing . . ." Then a lot of silent fumbling.

"Anyway," he continues, still looking at the remote, "I think that Howard lived his life with a sigh of relief. As you point out, by contemporary psychological standards, he probably was somewhat mad, but, as far as I could tell, he was not tortured or in pain in the least. He was a lot happier than most people I know. Really. Because of Jesus." He smiles, but it isn't derogatory as much as for emphasis, or out of habit. "He staked everything on his belief. It was the fuel of his art. The greater message of Howard's art, for me anyway, is that if he, after all of that suffering, could come through and live as a truly free and peaceful person, then you should be able to also."

Once the VCR is ready, I sit cross-legged on the red shag carpet, a couple of feet from the big TV screen, and watch David's tape for a few minutes as Finster sits on his porch and plays an old gospel tune on the five-string banjo. He seems shockingly older than when I first saw him at the Naro in Norfolk, with an ink-blue age spot on his lower lip and skin like rice paper stretched over his skull. He sings:

Just a little tack on the shingle of your roof
Just a little tack on the shingle of your roof
Just a little tack on the shingle of your roof
 To hold your house together.

"This is the part I wanted you to see," David says. He fast-forwards, pauses, freezing Finster's face for a second, then lets the tape play.

Exhausted-looking, nearing death, his lips chalky and dry, Finster, a ghost projected out of a technological box, faces us and in a strained voice says, "In Heaven there's going to be lions layin' around, with babies on their paws. And things you've never thought of, never even dreamed of. If Jesus was coming now the dead would immediately be raised and you'd look through these treetops here and see them flying over like jet planes everywhere . . . "

He plinks the banjo strings, licks his dry lips, raises a hand. "The vision God showed me was that the sting of death is *nothing* to His people . . . My imagination is, when a fellow walks into the Holy City, and the heaven above, that he'll plumb forget about this whole thing down here. I doubt if there will be anything in this world right here now that would even stand a chance of being praised. It just wouldn't be worth it."

When the tape stops, there is a moment of silence. I look at the carpet, then up at the cardboard face of Elvis, then at dust flecks flying jerky patterns through a shaft of window light. Neither David nor I have anything to say. Finally, the VCR clicks and the television suddenly hisses and brightens with static snow.

THE SECOND NOTEBOOK

Revelation Theories

And when the day of Pentecost was fully come, they were all with one accord in one place. And suddenly there came a sound from heaven as of a rushing mighty wind, and it filled all the house where they were sitting. And there appeared unto them cloven tongues like as of fire, and it sat upon each of them. And they were filled with the Holy Ghost, and began to speak with other tongues, as the Spirit gave them utterance.

ACTS 2:1–4

It is characteristic of the Saturnine temperament to blame its undertow of inwardness on the will. Convinced that the will is weak, the melancholic may make extravagant efforts to develop it. If these efforts are successful, the resulting hypertrophy of the will usually takes the form of a compulsive devotion to work.

SUSAN SONTAG

7

In July of 1989, the South Carolina painter William Thomas Thompson, who was not yet a painter, went to Hawaii to receive treatment for a mysterious and paralyzing nerve disorder. He was traveling with Janette, his childhood church sweetheart at Gum Springs Pentecostal Holiness in Greenville County, his wife of thirty-five years.

Thompson was fifty-four years old. He wore suits with a cross sometimes pinned to his lapel. He had never thought of painting. He had no interest in art—a frivolous endeavor at best, ungodly at worst; it did not exist in his business- and church-oriented life. If he thought of art at all, he understood it to be a product of the lost, the questioning. Good evangelical Christians are secure in the Lord, emptied of questions.

Janette had always been the creative one. She sold wedding supplies, arranged flowers. She liked Norman Rockwell and N. C. Wyeth. She liked pretty things, images of comfort and joy. Flowers and charming figurative scenes were nice but Christian art was the best—baby Jesus in the manger; wounded Jesus on the cross. She didn't remember who the painters were (Rembrandt, say, or Georges de la Tour); it wasn't about that. It was the

subject matter: the Lord, the King of Kings, the Savior. She wanted His face in every room.

Until 1988, until the bankruptcy that took almost everything they owned, the couple had run Thompson Import Floral Company, a silk flower and artificial decorations business once worth well over a million dollars. By the time of their arrival in Hawaii, they had lost their massive, opulent Tudor home ("The New Edinburgh"), approximately a hundred acres of land, all property and assets related to the failed business, and most of their savings for legal cost to fight what Thompson still believes to be a demonic conspiracy of the Masons within the American legal system.

They were both from farming families and children—like Finster, like my grandparents—of the poor South. They had started in business in the late '50s with money saved while Thompson was in the military, in the Army Signal corps, stationed in Fort Devens, Massachusetts. They had built Thompson Import Floral up over the years from their first five-and-dime on the edge of the "colored part of town" in Greenville, South Carolina—had worked six days a week, morning to night, and, somehow, become rich, "blessed by God." And then everything, even hope, disappeared.

In Hawaii the Thompsons were staying for free at the University of Nations in Hilo, a missionary organization that "trains preachers and sends them all over the world"—an action the couple had financially supported for years, until they could no longer do so. This stop over in the islands came after tying up loose ends in Hong Kong, where they had, with scant knowledge of international trade laws, opened an office, which precipitated, according to Thompson, their financial tragedy.

Here on little money and credit, they sought whatever free medical treatment they could get for Thompson at the veterans'

hospital. Because during the bankruptcy Thompson had started having trouble holding plates and cups, then he began falling down, crashing heavily into things, walls and furniture. It was like the world started moving under his feet, pitching him to and fro. Finally, one day in the midst of the legal proceedings, the calls to lawyers, the trips to court, the filing of papers he didn't understand, he couldn't move his legs. They were two logs on the mattress in front of him. And his hands curled like hawk's claws and shook if he raised his arm.

So much of this time is a blur, though, he will later tell me, painful to remember, but what happened next, the beginning of the outsider art narrative, is still very clear to him.

He needed a wheelchair to get around the islands, see the sights, go to the hospital and to church. So one day near the end of the trip, just to get out, to breathe the warm light and clear his head, Janette folded up the chair and put it in the trunk of a car. Thompson recalls that there were four of them from the University of Nations—he, Janette, and another couple with their faces erased by time ("I can't remember their names").

It turned into a tour around the island, in the fruit-smelling sunshine and the wet heat. They drove on the coastal road— mountains, the moving shadows of bamboo and tall palms; tropical humidity without the breeze like a sun-drenched fog, like breathing through wet cotton.

They wanted to pray, to worship. The driver suggested they stop at a "humble, little" church in a valley near the coast: several posts and a wood-framed roof, no walls to keep out the day. Under the plyboard ceiling, the congregation was animate— mostly islanders, sweating, waving their hands, praising.

On stage the preacher, one of the few Caucasians, was "like a Hell's Angel," heavy and coarse and tattooed, newly converted and "so happy in the Lord," happy to be there, alive, testifying.

But he hadn't worked the kinks out of his sermon: he was cursing, and stumbling over his words, and he didn't know his scripture either, not exactly a Bible scholar.

Thompson sat in his wheelchair at the end of a row of fold-out chairs. Birds chirped. Car engines hummed on a nearby road. He half-listened, then listened, then daydreamed and prayed, then listened again, thinking about his own life, his ruined body, his loose, worthless limbs and bent hands, his anger, the unbearable pressure of his sorrow. ("Some people just blow their brains out," he will later say when we discuss depression. "Some people just put an end to it.")

Half an hour into the rough sermon, without warning, without a tremor of prelude, as the born-again biker praised God in a shout, the church disappeared. Just went away. A roaring filled Thompson's ears. He was suddenly floating "as if in space." He saw fire, a wall of it—bright, rushing flames devouring everything, destroying everything, like an orange flood rolling over him. He disappeared within it—there was no resisting; that would have been like throwing your hands up in front of a mushroom cloud. He saw then, he says, all of Revelation—the horseman of the apocalypse, the woman on the moon, "that old dragon Satan," and finally the new Jerusalem and the coming of the Lord . . .

Moments later, when he came to and looked around, it surprised him to find the church, the people, intact.

How long had he been gone?

How long had he been floating above the world?

Janette was beside him, as before, listening. Same old Janette—heavy, reserved, practical, soft-spoken. Solid as ever, after all this loss, after all these years.

The preacher went on testifying, mixing the gospel with his childhood, back before the first tattoo, offering up a tragic

autobiography of shame and deceit, all the ways we are mortal and broken.

Thin clouds inched in from the Pacific.

The congregation waved their hands.

Someone shouted amen.

Only once before had something like this happened. It was in Houston, in the mid-1980s. He was on a business trip. He wasn't crippled yet. It was so strange. It was like he started dreaming while he was driving on the interstate. Acceleration, movement, a drifting in his thoughts, you know how it is, you're driving and you're driving . . . and then time slowed, as if in a movie, and there was a squealing, the first sounds of metal touching metal, and then everything shifting into fast motion, hypertime—the blunt force of *halting*; that awful crunching, as loud as a bomb; the hood folding like a piece of paper; liquid something raining all about the car, hot when it touched him. He thought he was going to die, was dying.

But then there wasn't . . . *anything*. No crash; usual traffic, usual sounds, usual sky; he was fine, driving along, radio on the Christian station.

Perhaps he thought of this the night after the church service. What was real?

He kept seeing the colors, his revelation, as he calls it, our complete annihilation—then the church again, the preacher, blue sky; here came the breeze.

He had a hard time sleeping. He couldn't tell Janette about what he had seen, about what had *happened*—it *did* happen; he has never doubted that—because he'd been so down lately— the illness, the business, the trouble sleeping. She was already

worrying about him. He was angry all the time, behaving strangely. He threatened to sue judges, lawyers, to file injunctions. Later he would threaten to sue his own family "for abuse." He was raving and raging. He felt "loosed from everything." There was talk among family and friends about how he was holding up. Tragedy upon tragedy. Who can take it? "Some people just blow their brains out, you know."

He still can't say why. It's one of those things that won't fit, quite, within language as we have it. But he had to paint it, the vision. He "burned," he says, with a need to paint a picture, to hold still these thoughts and images, the experience, the feelings he thinks were of God, which perhaps *were* God.

One morning, three days after the church service and the vision—three long days of not knowing what to do, of rolling around his room in the wheelchair—he got someone to drive him to an art supply store, where he fearfully asked a clerk, a young island woman, about what one needed to paint a picture.

The clerk looked at him—one of the Christian tourists, a well-dressed, near-elderly man in a wheelchair with a gray 1950s pompadour and giant glasses enlarging his blue eyes. "Brushes," she said. "And"—I imagine a pause here—"and paint."

Half an hour later, he rolled his wheelchair over to a picnic table in the sunshine outside of the store. A woman came by, like an angel, he says, to help him set everything up. He was finally ready to try to paint the vision. He had trouble holding a brush, his body so palsy-stricken that it swung in his hand like the needle on a liar's polygraph. He looked at the blank canvas. He looked and he looked and he looked. He says, "I felt afraid for my very life."

8

"I should start by saying I didn't know this was going to happen to me," Thompson says. We're in Baltimore, Maryland, Thompson and I, sitting in the cloyingly hip and upscale Joy America Café on the third floor of the American Visionary Art Museum, one of the largest museums devoted to outsider art. At the bottom of historic Federal Hill, the museum sits along Baltimore's Inner Harbor, which is deep green-blue and undulant out the window to my left. Thompson has been telling me again about the vision.

I heard stories about Thompson from several people while visiting Paradise Gardens. A journalist told me he was one of the "most interesting outsider artists working in the South." A Birmingham trailer court manager and self-proclaimed street evangelist who looked like Doug Henning, or maybe a cross between Jesus and the watermelon-smashing 1980s-comic Gallagher, referred to him as a "fierce Christian." His story reminded me of August Natterer's, one of Hans Prinzhorn's "schizophrenic artists." Natterer was a successful businessman with a stable domestic life. However, in 1907, after a descent into depression and a failed suicide attempt, he was hospitalized and began to document, in drawings and paintings, his visual hallucinations.

According to art scholar Colin Rhodes, "when [Natterer] be-
came ill he constructed a . . . detailed delusional system where
he was to complete the task of redemption that Christ had left
undone from his position in a global hierarchy in which he was
the highest authority. Natterer's transformation was marked by
a profoundly affective epiphany; a primary hallucination consist-
ing of a celestial stage or screen on which ten thousand 'pictures
followed one another like lightning,' including a vision of God."
When I returned home from Georgia, I went back through my
file on Thompson.

On his website, www.Thompson-art.com, and in several
newspaper and journal articles, I read up again on how between
1994 and 1997 he painted a 300-foot mural (six 50-foot can-
vases his mother helped him buy) depicting the vision he had
in Hawaii called *Revelation Revealed*. In 1999 he painted a 175-
foot version for Expo 2000, a Christian missionary festival in
Lausanne, Switzerland, where Dubuffet's original art brut mu-
seum is located, which Thompson was unaware of at the time
(he's now on their mailing list). By the early 1990s he was able
to get out of the wheelchair and use crutches, though he is still
severely handicapped, with shaking hands, weak shoulders, and
a difficult time controlling the movements of his legs. He has
essentially sworn off all doctors and treatments, though he was
once diagnosed with Guillain-Barre syndrome, "a temporary in-
flammation of the nerves," according to my wife's medical dic-
tionary, "causing pain, weakness, and paralysis in the extremities
and often progressing to the chest and face," and a diagnosis he
doesn't believe. He does believe, however, that, as with lawyers,
most doctors are Masons, thus in league with Satan.

By 1994—in the attic of his home, with his crutches propped
against the wall as he at times lay on his stomach or on top of a
canvas amid smears of color—he had already painted (and writ-
ten scripture on) over five hundred paintings, small and large,

with whatever religious thoughts moved through his mind. In 1999 the Museum of South Carolina in Columbia included him in a show of the one hundred most important artists of the twentieth century to have come from the state. His work, including *Revelation Revealed*, has been shown in many major and minor galleries in the United States and Europe. A portion of *Revelation Revealed* appeared on the cover of *Raw Vision* 33, and Thompson's angry, obsessive religious paintings—the smaller ones often done in less than a day, in a sort of trance, and looking like a jittery mix of the raw products of an indoctrinated Christian child and the late, art brut–influenced German expressionism of Otto Dix—have already been featured in two different exhibits here at the American Visionary Art Museum (AVAM).

He has just finished his lunch, which took him, with his shaking hands, more than an hour to eat. His tone is measured and articulate—like that of a small-town lawyer or a real estate salesman. Yet he looks like a painter or a Quaker, wearing a crisp black suit and gray shirt, open at the collar, exposing wisps of white chest hair. He is in late sixties, and his handicap seems to have added years, though later, at his home, he will tell me he is studying how to live to be one hundred and fifty, "reading books on the subject."

Tonight his work—a large, provocative collaboration with the more conventionally trained and "talented" Wisconsin painter Norbert Kox called *Idolatry: The Drugging of the Nations* and a smaller, solo painting of his entitled *Don't Be a Turkey*, about, he says, the dangers of flour, sugar, and salt, which he believes may have contributed to his ailments—will be featured in the opening of the new exhibit, Ascending Addiction, curated by the omnipresent Tom Patterson.

Thompson knuckles his large, black-framed glasses, sliding them up the wide bridge of his nose—wet eyes the size of silver dollars in his lenses—and picks up where he left off before the

waitress came and cleared his dishes: "I didn't know I was going to paint the book of Revelation. After months of struggle I had to throw away everything I had learned in the church all my life and start fresh. But I can't handle the Greek or the Hebrew [Bible], so I have to take it from the King James, which has changed a lot, I'm learning more and more. The name of Jesus didn't start with a *J*, you know. It was Yesu. With a *Y*."

I wonder if he doesn't just attribute that to how all language changes over time, like Geoff and Jeff.

He glares at me, then explains that the change of the *Y* to a *J* is evidence of the church's tampering with the true word of God.

I'm not sure how to respond. Thinking of our previous phone conversations, I ask, "So you said you understand Revelation differently now, since painting it."

"Yes," he says, "it was revealed to me."

"Revealed to you while working on the three-hundred-foot painting for three years or in the vision you had in Hawaii?"

"No, no. Not the vision. People make too much of that. People always write about that. It's out of proportion. They say, 'He saw this vision during a church service.' I mean it's true about the vision. I did have a vision of the end of the world. But all of this is bigger than the vision."

"But you started painting after the vision, right? That's what you told me on the phone."

"Yes."

I think of how the vision, in a way, is everything. Without the vision the outsider art world would pay less attention to his paintings. His eccentricity here—in a museum and a field where the biographies are traded as much as the art—is in direct accordance to his value as an artist (and he is highly valued at the moment).

"So how is it bigger than the vision?"

He shifts in his seat, pushes up his glasses again, glances at the Olympus Pearlcorder J3000. Clank of dishes from the kitchen. The bartender is talking to a tattooed girl sitting at the bar about her infected spider bite. "Brown recluse," she says. "I always thought they like lived in Africa or something." She's wearing a Ramones T-shirt.

I look at the menu beside Thompson, which is meant to look like a piece of outsider art, something cobbled together out of sticks and string and cardboard by a savant in the back office. For a place that must spend a lot of time pondering "authenticity" and Dubuffet's "art brut," this menu, along with the fact that you can have cocktail receptions and "visionary weddings" here, strikes me as intellectually—maybe morally—tragic. You, the art consumer, are invited to witness the raw expression of the marginalized and the disenfranchised, have a nice, pricey meal, then go wait in the beltway traffic like everybody else in the D.C. area.

Thompson clears his throat. He's thinking. "These things I paint." He pauses. "They were always there. I received the Holy Spirit when I was thirteen. My brother Jimmy had been called to the ministry, called out of our Baptist Church across the road from our dairy farm outside of Greenville and into the Pentecostal faith. I converted to Pentecostalism when I was thirteen. We call it full gospel. I don't know how much you know about this. I received the Holy Spirit through sanctification, through seeking God. I remember the feeling of the Holy Spirit entering me that first time." His eyes fill abruptly with tears. He swallows. A full minute passes. The *clink-clank* of dishes. Low buzz of other conversations.

"But I don't agree with the church anymore," he continues, wiping a clawed hand across his cheeks. "That's mostly what I paint about. You said you wanted to know what my work was about and why I did it. That's it. The church teaches lies. The

ecumenical, one-world church is of man. I'd like you to write that down, that I said that. Put it in your book. The church is antichrist—no longer of Christ."

I write it down. I say, "You mentioned the antichrist on the phone."

"Yes. The pope," he says. He pauses. Bent, shaking hands slide glasses back up his nose. "I don't know what your faith is . . ."

"Undecided."

Deadpan look. "The pope," he continues. He looks around the room, as if he thinks some Catholics might be listening. "Given all the evidence, it has to be the pope. Now the sexual molesting on top of everything. But there is also a Masonic conspiracy. The Catholics and the Masons have all the power. And the Jews, of course. Jews control all the money. The evil trinity is the Catholics, the Masons, and the Jews. If you were a Mason and you were pulled over by a police officer you would just give him a special look and he'd let you off. Or if you were in a courtroom—the same thing with a judge. I learned all about this when I went through bankruptcy. The Masons rule everything. They are in every seat of power. They can ruin your life, take everything from you. They need to be exposed."

"Rebecca Hoffberger," I say, "the head of this museum . . . Jewish."

"That's right," he says. "And we're friends. She's been very good to me. But I can't change my message, you see. I'm not sure how Jewish she really is."

"Do you think people understand your message?"

"I don't know."

"You could lose some support in a place like this if they did, don't you think?"

"Maybe."

I make some notes.

"The real Jews," he says as I am writing, "the chosen people in the Bible, were from the lost tribes of Israel. They settled in Western Europe and became Anglo-Saxon, like you and me. People talk about Jews as the chosen people but they don't understand they are talking about the wrong Jews. Jews as we know them are probably from the tribe of Esau. Not the chosen people at all."

"Let me make sure I'm getting you here," I say. "Jews as we know them are simply Hebrews, you mean? In other words, *not* the chosen people of God talked about in the Bible? So the chosen people, then, in your view, are White people?"

"I think so. I'm still studying up on it."

"I see. Seems like the main gist of our conversations and emails has been about power and corruption, corrupt institutions. Who's to blame, for lack of a better way of saying it?"

"Oh yes. Have you read the book of Revelation?"

I nod.

"Good. Good. That's excellent. When we first talked and you said you were an English professor, I wasn't sure whether you'd have much biblical knowledge. Not very fashionable. Anyway, what do you think of it, Revelation?"

"Not sure," I say. "Complicated. Some people, you know, view the book metaphorically or symbolically, see its ultimate meaning in the fact that everyone eventually ends up on their knees, so to speak, and needy. Part of being has to do with pain and decay. Language tries to capture this, make sense of it. I'm actually paraphrasing something I heard a Unitarian minister say not long ago. I'm very interested in religion, and philosophy as it applies to spiritual matters and mortality." I tap the cap end of my pen on the table, and hear some of the bull-shitty self-importance of my comments. I try this: "You know where I'm a professor they teach the Bible as a work of literature, a

series of texts written by men in particular historical and cultural contexts. That's pretty common at all universities. I don't know if you know that. I'm not answering the question, am I? Let's say I find it a fascinating text."

"A 'text'?" He frowns. "God said we would distort His word to suit ourselves."

"Is that what I'm describing—distortions?"

"Of course." He laughs, the first time I've heard him, and it is high and mocking.

"What do you think of it, Revelation? What does it mean to you?"

"Well, you've got to strip off all the doctrine [he pronounces this 'doctoring'] that's man-made and see if it's genuine, see if it really is the word of God."

"How would you do that?"

"I believe the Bible contains the word of God—the true word of God, the original word of God. But I can't say that it is the *absolute* word of God. I think that in the translations it has been changed some. I think the spirit of God will lead a man or woman individually to the truth if they commit to it."

The waitress—tattoos, a nose ring—comes and pours me another cup of coffee.

"It's important to understand that Revelation has been largely fulfilled," Thompson says. "We live in a corrupt world. Christ is coming. From what I know about the prophecy, the way I interpret it, I believe that Christ will return and rule the earth for a thousand years. We will be changed instantly into a glorified body that will live forever, the saints at least, the saved."

"A while ago," I say, "I heard Howard Finster say that when Jesus returns the dead will rise up and fly overhead like jet planes."

He shakes his head. "I had great respect for Reverend Finster. I painted a picture of him once. So there might be some truth to what he said. But that's rapture doctrine. You have to understand

first that the rapture doctrine was generated in 1582 by a Spanish priest. I believe to take the focus off of the pope as being the antichrist. And it lay dormant for a couple hundred years over in Spain. The Puritans discovered it and immigrated to this country and brought it with them."

"Hold on. You mean Revelation? I'm not sure I follow."

"No. I mean they brought over the idea of *interpreting* the book of Revelation to say there would be a rapture of the saints and there would be seven years of tribulation. That's one reading of things. Scripture leans toward a rapture, a raising of the dead when Christ returns, but it doesn't *say* rapture and I don't think it means rapture for everyone. I believe that Christ is coming and that we will be changed into a glorified body that will live forever and that the resurrection of the dead will take place, but it might only be the saints. I'm not sure about the dead who are unbelievers. I don't think Adolf Hitler or Saddam Hussein or people like that will rise up. I've heard it said that they will only be judged after the thousand years of peace."

"So then some people will stay dead for a thousand years and then rise up only to be judged worthy or unworthy?"

"I can't say for sure, but that sounds right."

"We're close to the end, then?"

"It's now the time just before the thousand years of peace under the rule of Christ. Six thousand years and another one thousand years equal seven, which is a complete number with God. So yes, the end of *our* time."

9

The mind as a prison. Living inside narrative. Living inside metaphor.

In 2001, after my memoir about my brother's mental illness came out in England, I was a guest on a talk show on BBC radio. The show, if I remember correctly, was about how life-altering it was to grow up around acute mental illness. The other guest was a psychiatrist from India whose sister, a schizophrenic, believed spirits communicated to her directly. She, like my brother, after years of odd and sometimes dangerous behavior, had helped to darken the big, black bags under the eyes of her family members. Our talk was a mix of reality-radio confessional and intellectualizing (the BBC, after all) about how we go mad within the language and cultural symbols provided us by our lives, present and past.

After the taping of that show, which had happened across continents, between London, a National Public Radio affiliate in Virginia, and India, I remember feeling a jittery uneasiness, like an itch below the skin, about having been portrayed as some hero-survivor, a success story. I felt, in fact, after a couple of interviews about the book, that I had done nothing more than sell my tragedy in an *au courant* literary form, the trauma memoir,

which courts, in this cultural moment, self-aggrandizement, even if that self-aggrandizement is half-buried under irony or self-deprecation. What had I done for my brother, or for schizophrenics? Made a few bucks for myself, become a "writer," and received some praise for my "bravery"—bravery?—and crisp prose style.

After that, I spent a lot of time in the dark Virginia farmhouse where I lived then, and looked out the window at the cows shitting and pissing and eating in the drought-thatchy fields. I reread Emerson and De Quincey and Walter Benjamin, read *Roland Barthes* by Roland Barthes, which had me doubting everything about my own autobiographical effort, read Paul Bowles's bleak tales about Westerners punished for their arrogance, and Beckett's existential monologues ("I have enough trouble as it is in trying to say what I think I know"), read a slew of crime novels *because* of their clunky, ordered plots, and then—somewhere in all this reading, I can't remember where (maybe volume 1 of *Tristram Shandy*)—I stumbled upon mention of John Locke's *Essay Concerning Human Understanding* and his radical materialist suggestion, especially for 1690 when this sort of thing could have you swinging chicken-necked and pop-eyed in the drizzly European courtyard, that organized religion itself was a kind of "folly" or madness. Folly is as much the commodity as art at AVAM, but the particulars—the idiosyncratic essence of folly—don't seem to matter. There is, as far as I can tell today, no attempt to get below the surface of things, to understand the making or the makers of this art. Folly, madness, or just extreme eccentricity is the frame around the picture, what draws your eye to it. And Thompson, in the context of the secular outsider-art world of dealers and collectors, looks pretty whacked out, frankly. But if you ever find yourself, as I sometimes do, buying coffee and a Power Bar at a 7-Eleven in the Bible belt, where the clerk is maybe telling the guy by the coffee machine that the Lord

saved her baby from that fever, or the Lord helped her get her credit straight, or the Lord is holding her poor mama in His palm right now, Thompson seems more like a product of a few grim tragedies, a cultural *place*, and a *state of mind*. So far today I'm swimming in garden-variety Southern, white, right-wing, tribal paranoia—which I've been in the vicinity of for most of my life—albeit turned up about ten notches. And Thompson seems to be a solid participant in what I recently heard someone—a Jewish female professor, in fact—refer to as the current "Christian fundamentalist revolution" in the United States.

That's what I'm thinking, and keep thinking as Thompson and I walk through the downstairs gallery.

Bright floors, red walls, high ceilings; separate, connecting rooms housing thematically linked works. AVAM is an architectural marvel; it isn't the new MoMA or the Getty, but it's curvaceous and sleek and posh, with its wall of glass half-filled with the harbor.

I look at the paintings, sculptures, assemblages. Thompson moves jerkily on his crutches.

Here is a matchstick bust made by Gerald Hawkes, an African-American heroin addict who recently died of AIDS. It is intricate, genuinely beautiful, I think, "underwritten," as George Steiner wrote in *Real Presences*, "by the assumption of God's presence." Thousands of matchsticks in the perfect shape of a head wilt me for a second. I feel the wind of my old sorrows tickling up my back. I think of the hours, the concentration. An image: my brother's Bible, the whole text obsessively annotated, drawn in, written on, responded to. What the thousands of words said in paraphrase: *Save me*. The comfort of a mission. It's how Thompson lives. It's how I live, too, in my way, working on an essay, a book, putting words on pages, moving them around, most engaged and at ease while working, least engaged

and at ease while not working, while standing stock-still on the periphery, the whole world drifting by like pictures on a movie screen, the story not making sense. In this way Thompson and I have some things in common.

I linger over the bust until he says something I miss. We move on.

I peruse works by the fundamentally religious, but also by mental patients, addicts and alcoholics, people who committed suicide, prisoners, the poor and homeless. Like a warehouse of good old marginalization. Colors and despair. Flowers in a graveyard.

I notice some barely known artworks—acrylic paint, spray paint, and collage on wooden doors—by William S. Burroughs, with the titles *Drug Hysteria* and *Rx-Morphine at Dawn*. And over there, on the left wall, are works by Linda St. John, owner of the trendy New York clothing boutique D. L. Cerney, whose memoir *Even Dogs Go Home to Die* was reviewed jointly with a collection of stories I wrote in the *Chicago Tribune*, the two of us lumped together, in the mind of this reviewer, as exponents of some sort of neobeat aesthetic. And maybe there is some truth to this. At nineteen, at twenty, as I bounced from job to job, from fishing dock to pouring concrete to house painting, before I had even mastered grammar, to be honest, I read Burroughs's *Junkie* and *Queer* and was floored; and then there was Louis-Ferdinand Celine, Knut Hamsun, Nathaniel West, Jean Genet, Alexander Trocchi, John Fante, Charles Bukowski, Norman Mailer, Joan Didion—all "beat" in their way. But these writers are *far* from being outsiders; they are, rather, intimately familiar with the *inside* workings of culture, each of them writing to subvert, to revolt. I read them, I'm sure, for some of the same reasons I listened to the Sex Pistols and X as a kid and jumped over fences to skateboard illegally in empty winter pools. The parameters of Roger Cardinal's "outsider art" are clearly up for debate. As

Colin Rhodes writes, "There is a danger of the term [outsider art] becoming all-inclusive and therefore meaningless."

This critical discomfort and these questions are mine alone. Thompson pays almost no attention to any of the art except his own, would not bother to ponder distinctions between Gerald Hawkes, a poor heroin addict from the ghettos of Baltimore, and William Burroughs, a heroin addict who shot his wife and shot up in Warhol's Factory, who was presciently aware of how the joke of American celebrity culture and product-consumption-as-identity would soon become our religion, who was a hero of the American underground, and who recorded the spoken-word "Star Me Kitten" with R.E.M. on the album *Automatic for the People* (the web of connections!). Thompson is either so obsessed with what he sees as his "art ministry," or so encased in his own churning ego, or some combination of the two, that he rarely notices other things—people, life.

As we walk, I ask him if he has read anything about outsider art. He is, in his demeanor and social skills, a polite and often reasonable man who might have been troubled by this. Does he wonder about how he is categorized and viewed by places like this or by journals like *Raw Vision*, which mentioned and then never explored his "road-to-Damascus" vision, barely touched on his extreme fundamentalist thinking—a hard sell to secular art browsers and buyers—then praised, with clichés too common to outsider-art writing, his "remarkable Revelation murals" and "unmistakable style which owes much to the lack of normal control of his arms and legs caused by his illness."

"No. Not really," he says. "It doesn't interest me. I did once start to read a book about it and all the people were deranged. They were schizophrenics and retarded people. Patients in hospitals. People living in shacks or on the streets. It bothered me. I'm not like that. If a person goes into an asylum and paints art while they're in there then their work seems to be worth more.

When I looked at that book, I didn't want to be included. I don't feel that's my case. People automatically assume you're crazy if you talk to God."

"You mentioned the Holy Spirit," I say, "that you feel it when you paint the same way you felt it during the vision. I imagine that's the kind of thing a writer might seize upon."

"Right. I do feel a supernatural power, feel that I can do anything. The way they did on the day of Pentecost. I'm not ashamed of that. I'm not ashamed of my belief. I don't think that makes me crazy."

Thompson, not long ago, told me about how Rebecca Hoffberger encouraged him after his first show here to study Buddhism, a religion he refers to as "heathern." I can't get over the obvious incongruities and oppositions, his beliefs and the beliefs of the people showing and viewing and buying his work. And the fact that Hoffberger mentioned Buddhism to him perhaps shows how it is in her best interest not to try to intimately understand the rationale, "the private theatre," behind some of the art she is showing. Thompson told me she refused to show his paintings that depicted the Holocaust and Jews, and that they had "a blow up" over it, though he didn't want to go into details. What might Thompson say about Buddhists? That they are all going to hell, for starters.

There is a great moment in John Berger's *Ways of Seeing* when he shows the reader Van Gogh's *Wheatfield with Crows* and then shows it again with the caption written beneath it: "This is the last picture that Van Gogh painted before he killed himself." This information changes perception. The way we see and interpret is suddenly charged by tragedy. Outsider art, once collected, often makes the caption more important than the painting for the sake of display. But rarely are the particulars beneath the caption, the actual thinking and mission of the artist, explored.

Maybe this is what Beverly Finster intuited when she said her father was "exploited." But it's complicated—because the "exploitation," if that's what it is, comes almost accidentally, naively, through the gestalt of therapy culture, the unavoidable social economy (the business) in which all art exists, and from those who believe they are being enlightened and liberal and humanistic in celebrating the work of the marginalized and the lost. It's the cult of *sensibilité* all over again, we enlightened folks feeling sympathy for the pathetic and damaged—poor them! Glad it ain't me! Obviously I am interested in the lives of the "marginalized," but I feel turning them into John Dryden's "noble savages" is one of the worst things we can do. And continuing to equate madness to freedom demeans, further disenfranchises. Here's a thought—how about treating these artists, these addicts and preachers and inmates, like people, letting them talk and listening. Show the work, yes, because much stands up as beautiful and strange work regardless of the biography, but what about solemnity, thoughtfulness? "Visionary" weddings? I'm waiting for a carnival barker to scream in my ear. I feel like I'm going to run into the bearded lady around any corner.

"It's over here," Thompson says.

We come to *Idolatry*, the first of four collaborations between Thompson and Norbert Kox that will later come to be known as *Elohim: The Apocalyptic Time Machine* and be described by the two (though most of this thinking, I feel certain, comes from Kox, the more cerebral of them) in this way: "'Elohim' is the Hebrew word we translate as 'God,' and 'apocalypse' is the New Testament word for revelation. The concept of *Elohim: The Apocalyptic Time Machine* is very simple and at the same time quite complex.

Elohim, God, exists in a limitless eternity, outside of our realm of measured time. According to Scripture he knows and sees the end from the beginning. This is what makes prophecy possible. He sees what has happened before we experience it. To him it has already taken place. All past, present, and future are recorded in the eternal archives of the omniscient Elohim. At times he chooses to allow certain people to glimpse the future. This is a prophetic revelation, an apocalypse of things to come, an actual view of God's memory. Since he holds all knowledge of past, present, and future, Elohim is a virtual time capsule, a time machine: *Elohim: The Apocalyptic Time Machine*."

Idolatry is a nine-and-a-half-by-seven-foot canvas that reminds me, at first glance, of a heavy metal black-light poster from the late seventies. The Catholic representation of the Virgin Mary with her arms outstretched is at its center. Mary's head, however, is a skull. Between her skeletal hands are stretched paper dolls being eaten at either side of the painting by dragon heads coming out from under her dress; these paper dolls, painted by Thompson, represent the "abortion mills." "Noitroba" is written on the crown—"abortion" backwards. The crown on Mary's head also holds up seven churches, which represent the ecumenical or "one-world" church, a big discussion topic among the Christian far right. There is small, white writing all over the black background, mostly verses from Revelation. At the top of the painting it says VICARIUS, which Thompson explains is the word written on the pope's crown. Vertically down one side VICARIUS is written again, but this time the letters are read by the artists as Roman numerals: V = 5; I = 1; C = 100. Thompson and Kox have this somehow adding up to 666 (Thompson did something similar, with the Latin word VICIVILIID, in *Revelation Revealed*), though I keep getting 106, which deflates some of the conspiracy punch of the painting.

Even after talking about it for several minutes, I'm still not, numerically speaking, getting it.

"It adds up to 666," Thompson says impatiently, "the mark of the beast. In Revelation it says to know the number and know the man. Social security numbers may be connected to the number of the beast."

On Mary's chest is the burning, severed head of Christ, painted by Norbert Kox, who is best known for his series of mawkish Christ heads. Jesus—"Yesu" to Thompson and Kox—looks like a screen print on Mary's T-shirt. He has a sword through his eye (this image upset Thompson's devoutly Pentecostal family so badly that they refuse to allow the painting back into their home).

The image of Christ's head, Thompson explains, leaning on one crutch and pointing up at the painting, is the "false image" of Christ painted by Warner Sallman in 1940, the gauzy, earthtone one we have all seen if we've ever been inside a church; the Sallman Christ, Norbert Kox's métier, is part of a conspiracy to lead Christians away from the true Yesu. This is not Christ, Thompson says, but the trickery of the devil.

I get lost in the explanation when Thompson starts telling me about the "important books of Ian Paisley," a fundamentalist Irish Protestant separatist who actually *wants* war with the Catholics. He says he has come to understand the true nature of the papacy and the mark of the beast by reading Paisley's books. I write Paisley's name in my notebook with "BOOKS?"

"So this collaboration between you and Kox is primarily a critique of organized religion?"

"Yes," says Thompson. "We both have Pentecostal backgrounds. I have Pentecostal Holiness. I believe he's United Pentecostal. I think that's what it is. You'll have to ask him. Anyway, we really agree on things."

Just as I am about to ask a question, a small, thirty-something woman with a mohawk and multiple piercings comes toward us, smiling. She's wearing faded cargo pants, a Hawaiian shirt, and combat boots. Around her left wrist are about fifty or so different colored rubber bands. A rainbow triangle button is on her collar.

"William," she says, happy to see him.

"Hi," Thompson says, smiling back.

They hug tightly for a moment in front of his painting.

Thompson introduces me to her. She asks if I'm an art writer and, after a second's thought, I tell her no, just a person who reports things. She's an art writer, "totally focusing on outsider stuff."

"William, I *totally* love your painting, man," she says, sticking her hands down in her pockets and rocking slightly on her scuffed combat boots—the gesture of a nervous teen. "I came and looked at it this morning. I mean, I really get it, you know. I get what you're *doing*. It's very powerful. Because I'm like totally down with spirituality, you know—I'm a very *spiritual* person—but not with all of the hypocrisy of religion. I go to this church in New York and we have a lesbian minister, you know, and it's all about love and joyful worship." She looks at me. She's seems to be talking more to me than Thompson now. I smile: love and joyful worship. "I had kind of a weird time in college, you know, when I was coming to terms with . . . *stuff*. And I went to a church and like everyone was totally waving their hands and it was like a weird cult telling you do this and not that and be this and not that, everyone all like *conforming* to this certain way of being and stuff." She plinks some of her rubber bands.

Thompson listens, smiling. I expect him to correct her, talk about Revelation and the pope and the real and false Jews and the Masons and how this is a pro-life painting—Noitroba, 666—tell

her about Jesus being a white guy, about Kox's Warner Sallman paintings and the *Y/J* conspiracy theory, but he doesn't. He smiles.

I'm baffled. I wait for a stream of fire to shoot out of his mouth.

Finally, the art writer says she'll see him tonight at the opening and they hug again before she leaves. Just before she walks away, a photographer—a guy with shaggy hair and Doc Martens and tattoos—who has been over in another corner looking at a painting, asks the art writer and Thompson if either of them have seen Tom, meaning Tom Patterson, and suddenly I feel like I'm at a party to which I wasn't invited.

"That seemed an odd exchange," I say as we walk away from the painting, back through the galleries.

"Oh," says Thompson. "How so?"

"Well, she just came over here—and she is an art writer, right—and completely misread your intentions in this painting, at least as you've just explained them to me."

"Not really."

"Not really?"

"It's about the hypocrisy of religion. It's about how people become addicted to religion in a way that does away with God. That's the core."

"But she sees it as kind of the standard secular critique of religion. You know, what Marx said: religion as the opiate of the people. She looks at that"—I point back in the direction of the large painting—"and sees you as a secular person. A person who left the church for some of the same reasons she left that church during college. Do you worry about this? Or do you wonder who your audience is?"

"I do worry about my audience," he says, the rubber tips of his crutches squeaking on the clean floor as we move again, the overhead lighting caught in the lenses of his glasses. "But I want my work, my message, to get out there. That's the most

important thing. I'm an outsider to the church. I know that. The church won't have my paintings. The outsider art world has opened its arms. This place." He pauses, looks around—at mayhem, abuse, addiction, suicide, insanity, and obsession. "You have to understand: I've never been more welcomed."

10

"You mean when are they going to have me committed?"

Thompson walks ahead of me in the huge third-floor painting studio of his Greenville home, the historic, forty-room Gassaway Mansion, which was built in 1919. December now. Toothpaste sky and clouds like pulled cotton turning in the windows. I arrived this morning, two months after our AVAM meeting, to continue the interviews. We're doing the tour.

This studio used to be a ballroom, a place for cotillions and receptions for the original, well-to-do Southerners, the Gassaways, who had the home designed and built and then lost it, Thompson says, after the stock market crash of 1929. Several smaller rooms orbit this one. The place where I currently live with my wife and children could fit twice, possibly three times, *on this floor.* Off from the main room are a confusing series of adjoining spaces—a few steps down to this one, a few steps up to that one. This room the size of a middle-class, suburban bedroom, that one closer to a two- or three-car garage, the whole set-up like one of those Escher drawings hanging in pot-smelling college dorm rooms all across America. And each room is filled with paint, paintings (literally hundreds from the size of a shoe box top to a barn door), canvases, and books, most of which

are fundamentalist Christian in nature, though I saw, earlier, an anachronistic copy of *On the Road*, another one of the "beat" books once dear to me.

High ceilings. Sawhorses and paint-flecked old tables in the largest room. Paint drips on the floor, crusted white and yellow like bird droppings. Some cracked or broken windows. Wind moves through the room. Dust bunnies levitating and falling in corners. The temperature inside is around forty-five degrees.

It took me a day of continuous driving and lower-back cramps and too much coffee and half of my CD collection to get here, and I have already insulted Thompson, an hour into the interview.

I stumble through my thoughts, backtracking: "That's not what I meant," I say to the back of his head, but he is no fool— as much intense businessman as outsider naïf—and clearly that is what I have just implied with a question related to his bouts with "depression": that he is troubled, that his family thinks he is troubled. I didn't come here to be condescending or patronizing. I'm just talking, recording, making notes, trying to understand him, his obsessive need to paint, below all the brimstone rhetoric and beyond the context of how his work is, I think, problematically exhibited at AVAM; but not *just* AVAM: his work has recently been or is currently being shown in galleries in Memphis, Tallahassee, Charleston, Las Vegas, New York, and Green Bay (he's "hot" in the outsider-art world, as one journalist put it to me). He has been, overall, generous with his time and gracious. We're not friends, certainly, but we're friendly. His wife fed me a breakfast of grits, eggs, and fruit. Interviewing people is more problematic than I imagined.

Actually, he brought up the depression topic, talking unguardedly about his daughter's nearly debilitating bout (she goes off by herself, shuts the door to a room, and reads the Bible, head in hands, leaving her husband to take care of their young child),

his deceased father's tendency to "go silent" and "hide away" from the family, and his own feelings of despair and dislocation throughout his life, how he always felt like a stranger to the world around him. I can't even recall exactly what I said a minute ago—something about outsider art's historical relationship to mental illness and psychiatric care—but he took it as judgment, took it personally.

"Sorry," I finally say. "I didn't mean to offend you, William."

Thompson's family situation is very different from those of most so-called outsider artists (as different as those situations might be in their particulars from one another). He lives in this historic mansion, which he bought, with only a small down payment, from the Emmanuel Christian Academy in 1992 for less than a hundred thousand dollars (he believes this to be a miracle; he had been driving around looking for a place big enough to store his paintings after his family threatened to burn them because of their dark and contentious messages when he noticed the home shining like a sign from God on the hill). He has a hard-working, conservative, devoted wife who makes a living organizing and putting on Christian wedding receptions in their rambling home, parts of which have been beautifully renovated, other parts of which, like this attic where I am shivering in a thin sweater and old jeans and running shoes, are still in a state of disrepair, near collapse. One of his daughters, a caterer for the Christian wedding receptions put on by his wife, his son-in-law, and his granddaughter live in a private apartment within the house, just down the stairs from us.

In other words, his family is not unusual in relation to other middle and upper-middle class Greenville families in many ways: church going, Bible quoting, reliably far-right Republican (Pat Buchanan and Robert Novak, at the invitation of Thompson's brother, a minister, came to Gassaway for a fundraiser in 2000; George W. Bush had breakfast at the Ham House in Greenville

in 2004, which William's brother attended as a VIP). And the Thompson family is clearly concerned with *appearances* in that classic bourgeois Judeo-Christian way (a certain china set always used for special occasions; bright flowers in Grecian-looking vases on antique tables; doilies at place settings; embroidered homilies about Christ, prayer, blessings, and home framed and placed on bathroom and kitchen walls, etc.). Yet here *he* is, carrying out an odd existence—certainly in relation to the way he lived as a businessman, a devoted member of his church, a pillar of the mainstream community—on the painting-filled third floor, creating an elaborately structured cosmology, in which he functions as something of a prophet, to underpin his everyday life. He writes an eschatological daily journal on his computer to post on his website (about six hundred pages a year of personal social criticism on everything from foreign policy to Christmas to anecdotal news stories to health fads), paints most days, and reads religious tracts and texts; he has become, if I am reading this right at all, a darker and darker puzzle to his family, all of whom seem to tiptoe around him and to regard his paintings not as impressionistic, naïve, and interesting, but as talentless and "awful," as Thompson puts it. Meeting the family downstairs earlier this morning, I sensed that they regard a visit from a writer not with reserved excitement but with dread because of what Thompson might say, because of what I will write.

We stop in an atrium, a bright light-filled room with spider webs in the corners and paintings of demons and biblical figures leaning against the walls, against chairs, against other canvases. And now, as the sun flings our shadows behind us on the floor, I say, "I'm just trying to understand some of the tension you've mentioned between you and your family concerning your painting. You've brought it up a few times. Depression. Family issues. Obviously these are things you think about." The tension here,

frankly, is much like the tension in homes with mental illness: a sufferer withdraws into their own "abnormal" thinking, and when that thinking seeps into the family conversation, there is a blow up, tears; later comes the worrying, the regretting of words, sleeplessness, a tangle of love and hate, tender feelings of sorrow, a wish to get away. Chasms appear. There can be no communication without conflict. Everyone lives on his or her own planet. I can see how someone might blame it all on the devil. That's what my brother called it. Maybe "devil" is a good name for it.

"My life, the way I think, causes tension," Thompson says. "My family hates my art. They mock it and think it's terrible. You should talk to my sister. She can go on and on about how terrible it is, how my people don't look like people. She's says it's like a child's scribbles. She says it's not even as good as what a six-year-old could do." He leans back, wobbles for a second— I think he might fall—then regains his balance. Anger, or maybe just exasperation—or possibly even embarrassment, I'm not sure—leaks into his expression. "No. They don't think much of my art. But what can they do? They tolerate me. That's about it. My son-in-law—and I don't want to get too much into our relationship, because I'd hate for you to write some big thing on that—sometimes asks me who the people are who come by to look at my paintings. He says he doesn't like gay people coming around his family."

"Gay people?"

"He thinks they're gay. The people who come by, who purchase my work. Maybe they are. I imagine some of them are. And I found this magazine"—he shows me a crumpled, stained copy of *Raw Vision* with a Henry Darger drawing of two little girls (horned and with penises) on the cover—"that had an article on my work in the trash. He saw it in the mail and threw it away because of what was on the cover. He thinks it's satanic."

"What do you think of the cover?"

"I don't know. I don't like it."

"But you're in here."

"Yes."

I wait. End of conversation. He walks on, one crutch in front of the other.

He is different at home, as perhaps we all are, edgier and less patient, a touch crankier than the person with whom I've been emailing and speaking on the phone, the one who's been talking so openly, so unguardedly, who cried talking about his baptism at fifteen, who smiled and nearly swooned at AVAM thanking Rebecca Hoffberger for including his work in the Ascending Addiction show. I keep asking questions. This has now dragged on over months. I haven't written a word.

Honestly, standing here shivering, I start to think that I *can't* write about him, that this is a dead end, that what William Carlos Williams once called the "tentative alliance" between writer and subject, one which might "fall apart at any minute," is indeed falling apart right now, on tape, in this room.

I've pursued Thompson with my ideas about pain and the transformative power of creativity, or maybe I mean creativity and the transformative power of pain, notions of unmediated expression and the healing process of *representing*. Not some sentimental thing about confession and catharsis, although that might be part of it, I should admit, but something baser, more primal, older, our need to speak and be heard, even if only by God, or our *idea* of God, and to somehow believe that our speaking matters, makes some small difference thrown up against the void. But now I'm over my head in ultraconservative rhetoric— not what I set out to find—with a man who sees himself as a professional painter and whose work is collected and shown (please take a moment to ponder the implicit cruelty in this) *because* he is, from a secular viewpoint, a right-wing, Christian

believer. Maybe, though, I'm all wrong about art, trafficking in one of the worst of the lingering Romantic and Victorian clichés about it; maybe art, this kind of raw art, this dirge and purge of internal blackwater, is as often as not a trap, a prison, just as Schjeldahl put it, a way not to free yourself from dark thinking but to entomb yourself within it.

I've been thinking that down below Thompson's rage—"rage" being the term he often uses, even sometimes referring to his paintings as "rage art"—is a sorrow like an open wound the size of a well, a sorrow to stand inside of, look up out of, understand, get into a form that might be of some import to a reader, of some psychological or cultural value, but there is no getting there, because we keep talking about the pope and Catholics and Jews and gay people and Masons.

11

"If there is any prejudice in my heart, any hatred, I want to get it out, to rip it out," says Thompson, sitting in a chair on the third floor, crutches leaning against his leg. The sun is two small circles in the bottom, left corners of his lenses. "I would like to live a life like Christ."

An hour later, tape still rolling, he says, "I've been thinking about something since we last talked. The Illuminati [those at the top of the satanic conspiracy] have to be . . . " he pauses. "The Hebrew people. All my research leads me there. People confuse Hebrews with Jews. Hebrews are not the chosen."

A couple of hours after this, tape still rolling, we're at the Dixie Outpost, a store Thompson likes to visit, looking around at Confederate flags, shirts, hats, holsters, hunting knives, and so on. I flip through a right-wing political magazines promoting

militia-like behavior—stockpiling weapons and food, setting up a "protective barrier" around your home or business.

The man who owns the store tells me that he opened it because he was tired of having to apologize for his race. He is proud of his race and wants to celebrate it. He hands me a flyer for a conference coming up in Greenville about how slavery was a positive thing for whites *and* blacks, how it made our nation the great place it is. Several local clergy will be speaking.

The owner's brother, who works in the store on weekends, is a full-time employee of the Greenville County school system, which has a large percentage of African American students. I'm getting ready to ask about the school system and his views when Thompson announces, "Mixing the races. No good has come of that." He looks at the owner. He looks at me. Maybe my face has tensed. "I'm just telling you what I've learned to be true."

12

The fourth floor tower, as Thompson calls it, is actually the attic, and it has a "Keep Out" sign posted on the door at the bottom of the stairs. His family is not allowed in, ever. He and I, however, walk up the steep concrete steps. I carry his crutches and walk behind him; he hangs onto the railing, slamming the bottom of his black, slip-on boots onto the stairs as he moves up them, which sound like two-by-fours hitting a picnic table.

He told me earlier that he now falls about once a day. He has cuts on his hands—deep gouges that don't look like they're healing well. He has fallen backwards down the main stairs, which make a right-angle turn. He has a hard time eating a meal, or zipping his pants, or making his way through a store. He gets nervous and agitated. He sometimes can't open a public bathroom stall without a pair of pliers, which he carries. Yet he often gets in his car, equipped for his handicap, and travels all over the country to art openings. His drive to make his art and show it, to preach to the world, his otherworldly willpower, just about comes off of him in visible waves.

Up here, in the attic, there is a weight bench, old paint cans, tennis rackets, and perhaps fifty more paintings stacked on tables or against walls. Hanging from several chains is the Holocaust

series that Rebecca Hoffberger, according Thompson, refused to show at AVAM. These paintings, on first inspection, seem literal and politically benign—Hitler sending figures into a gas chamber; nothing that hasn't been depicted thousands of times before—but I understand now that the "chosen people" were not killed by Hitler in Thompson's belief system. Non-Christians, *nonbelievers*, were subjected to wrath. Perhaps the Holocaust was a scourge against Hebrews (ethnic and religious Jews as you and I know them) in the way that AIDS, according to Jerry Falwell, was God's punishment for gays.

"This is what I want to show you," Thompson says, pointing to a twelve-by-four foot black and gray painting of a man-demon in a suit. It hangs from the ceiling, down one of the brick walls. Like all of his work it is one-dimensional and, well, "raw," with smears of thick paint applied to the canvas, but it has flair and lots of anger, if minimal technique. It is not, in its depiction of the human form—giant head and mouth and eyes, thin arms and legs—dissimilar to something you might see on a bulletin board in a second-grade classroom. "It's called 'Dickey,'" he says. "It's Richard McClelland, the lawyer who took everything we had."

"You mean in the bankruptcy? Sixteen years ago?"

"Yes. He tried to destroy us. I still have dreams about him. So I painted this."

In my notebook: *Attic like his mind.*

13

He says: "If you don't get killed pulling onto the onramp. The traffic around here. They're trying to kill somebody."

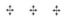

He says, later: "There was a shooting last night. Someone drove up and shot a kid in the car. Right in the head. Someone drove up and shot him. Just down the road. A kid. Right in the head. I think he was twelve years old."

He says, still later: "I believe fluoride and stress from the bankruptcy caused my illness. They know what fluoride does to the body. No accident there. And lawyers—they know the law, know how to manipulate legislation, know how to take everything away from you."

14

From Thompson's journals:

Daily journal April 30, 2001, Hallelujah, praise the Lord God
Almighty in Heaven and all over the universe where He is. What
means the most to us in life? Is it the love of God, or love of self? Is
it the love of money and pride or is it service? Someone e-mailed
me a prayer at 2:00 a.m. today and I needed it so very much. I cry
aloud to God for the healing of my body and mind. I pray for the
renewing of mind to recreate it. I pray for understanding without
confusion. I pray for the return of the opportunity that I missed.
Sometimes the Lord has to set us up and pour his blessings down
us. I have been a Jonah running from God but he has caught up
with me and my heart aches to please him. I used to pray in the
woods alone. The time when I had woods to hideaway in and
to pray in. Amos 3:1 "Hear this word that the Lord has spoken
against you, O children of Israel, against a whole family which
I brought up from the land of Egypt, saying, (2) You only have
I known of all the families of the earth: therefore I will punish
you for all your iniquities. (3) Can two walk together except they
agreed? (4) will a lion roar in the forest when he has no prey?
Will a young lion cry out of his den, if he have taken nothing?"

Dear Lord, help us in this serious time to turn hearts toward thee. Reveal Thyself Lord. Number 2 in pleasing the New World Order in living "Avoid talking about religion or politics. No matter how innocent your speech may be, it could be misinterpreted and recorded in your government personal thought dossier." Electronic surveillance now pick up certain words that may alert them to hostility. In other words play it safe and be quiet. The breath of the Lord God is within me and I appreciate everyday I have to serve Him. I daydream of when a surprise that they give me the land back with money to compensate for all the damage done somehow but I realize it is not going to happen that way. We've gone astray, the principles of God still apply to our daily lives and God will not tolerate slowness. There's never anytime to waste, people or dying without Christ in the world. Why should I need to compare now to the past and try to determine if I am better off or not. The court is stack toward a landlord mentality and that's why and how the laws are written but they are not all the law, only rules of operation in violating the Constitution.

I have been to Hell and back to identify the problem. Now I pray Lord that You will return the opportunity. I let the devil steal it all. I feel released with new energy in my feet and legs and I believe my healing is sure. I cannot block it out, I must face reality. I had to face it and I just did. My mind replays every word spoken and every site seen.

It has been said that teachers in public schools today spent 20% of their time teaching and 80% of part-time disciplining the kids. Discipline is not working and that is why we have so much trouble in the schools. The public schools are referred to on the public airways as a mess and I say that is an understatement. We have become a guarded nation with police guards in the schools and airports, every courthouse big time security. The atomic-like blast on planet Jupiter as seen last week is evidence that Atomic Energy has been in the universe forever but we are just now discovering

it and putting it to use. The condition in California and although the West Coast is trying for the average citizen living to pay the higher rent, 400% increase in some utilities like natural-gas and electric power. Water bills reported to be $200 per month and gasoline up again so high by 50%. At the same time the Silicon Valley crisis worsens with massive layoffs and improvement not in sight. We face a grave crisis in this country of hungry, sick and suffering people. This is a holiday in Red China and Russia when they show all their military hardware traditionally on May 1st it is a long weekend. The end is surely near of the day of grace.

15

As I am leaving for the day, heading back to the hotel, Jeanette stops me. She's wearing a lose denim dress and white sweater. "Here," she says, handing me a tape of the couple's fiftieth wedding anniversary. "I wanted you to have this. It gives a family history. If you're going to write about us, I want you to understand that we had a life, a good life, before the bankruptcy and . . . the art. The art story is just a small part of our story, Greg. William had a long life before what happened. He was a father of two daughters and a good businessman and a member of his church. He was a husband. He had lots of friends." She looks long at me, and I think she is wondering who I am and what I want.

"Thank you," I say, taking the tape. "I'll watch it."

"I just don't want you to think this is how it's always been. That wouldn't be accurate."

16

A coiffed man on my TV in the Holiday Inn is asking for a faith donation of eight grand. It has to be eight grand—the Lord came to him with that number, the number eight; he added the zeros. He knows that I suffer. He can feel my wanting to come out of it, to finally "get my feet on the ground" and "get ahead." He calls my eight grand a "seed," one I must plant and water with my faith.

Books spread out in front of me, legs crossed, leaning against the overly puffy pillow, I swig from a bottle of beer. Oh I'll water it, I tell him.

There are twelve of us out here, just as there were twelve disciples, and our aching is unbearable: ninety-six grand worth of aching, to be exact.

He feels it in his studio—our pain zinging through the wires and airwaves.

His hand is out, palm open (gold watch, gold rings, gold cross on his tie, American flag on his lapel).

Credit cards accepted.

Operators standing by.

Here is our web address.

"To begin with," writes William Gass in his essay "The Nature of Narrative and Its Philosophical Implications," "stories break up the natural continuum of life into events. Next, stories arrange these segments in a temporal sequence, in order to suggest that whatever happens earlier is responsible for what happens later In stories, there are agents and actions; there are patterns; there is direction; most of all, there is meaning. Even when the consequences are tragic, there is a point; there is a message, a moral, a teaching."

I get out my notebook:

1 As far as we might consider Thompson's behavior or belief situation *aberrant*, it is important to understand it, foremost, in its *context*. We're not talking about Auden here—an artist and intellectual, a worldly man, versed in the workings of culture, capable of serious abstract thought about Systems—having a religious conversion after a brush with existential longing, after coming to the conclusion that rational, materialist thinking will never deliver you at the doorstep of God, that, as Miguel de Unamuno y Jugo put it, "the vital longing for human immortality finds no consolation in human reason." No. Thompson's life has been one lived entirely *inside* fundamentalist culture. This is his place, his world. He has never doubted its central tenets—that we suffer in life, that God touches lives if we are open to Him, that we, if we believe and do not sin and accept Christ as our savior, will live forever in heaven with all the "good" people. His work, his "rage," his critique is *about fundamentalist culture* and all the ways it has become cheapened, has strayed from what he sees as, for lack of better word, purity. He is an uber-fundamentalist, and this man on TV, with his gold and his suit and his hairspray and his addiction to money, is a small part of what Thompson hates—what fundamentalist culture has become, what the

painting *Idolatry* is about. Thompson, were he here, would probably remind me that religion can't be relativist, that God is not a joke. It is people, it is this man asking for God's money—they're the joke, and not a very funny one.

2 A fact: The tension he has with his family, which is palpable, partly comes from his critique of the worldview and the lifestyle they have all shared since they can remember. Imagine: one of your family members locks himself away in the attic and starts painting and writing in an effort to convey to the world that everything you have believed your whole life, the institution through which you worship, through which you attempt to contact God, is filled with lies. Another fact: What makes Thompson interesting to outsider art museums and scholars is that his thinking and art are insular, almost, to the point of incomprehensibility. Fundamentalist culture is, obviously, way outside of the culture of art. But Thompson's work is an intricate fundamentalist critique, using language from the Bible, of fundamentalist culture. This makes his work truly "unscathed by artistic culture," which was an important part of Dubuffet's original conception of Art Brut. Outsider scholars, I speculate, are attracted to his work because its profound insularity—an "outsider" system of critique within an "outsider" system to begin with, creating multiple layers of Thévoz's "private theatre"—starts to look a whole hell of lot like madness, which to some extent it may be, and which is, if you ask me, the main currency being traded.

"Now is your time," says the man on TV. "Do not disobey the Lord."

I can't sleep in hotels.

17

"Basically everything that is not Christ, that is not *of* Christ, is anti-Christ. The world is anti-Christ, the devil is anti-Christ," says Thompson.

I have a headache—the bad mojo of alcohol, insomnia, muffled TV talk blaring through thin walls, and polyester bed spreads. I also have a warping sense of déjà vu.

Did this conversation already take place?

Saturday morning, sunny, a few dense tumors of cloud in the sky.

Thompson and I are standing in a gravel parking lot in an impoundment area in an industrial section of Greenville. Thompson is showing me the six buses he has recently purchased from the city "for cheap." He plans to paint them all over with "artwork of biblical prophecy," an action his wife and family think is "kind of hippie."

He is hoping the fundamentalist Christian artists Robert Roberg and Norbert Kox will take one each to paint. But they seem, so far, reluctant to take a bus that doesn't run.

Even if Roberg and Kox won't take one, Thompson plans to keep them and paint the buses himself, despite his family's objections. He won't be deterred by anything they have to say.

That would be openly defying God. He has been given a mission from God to reveal the truth, to show people the lying ways of so-called Christian culture. He understands that he might have to one day choose between his mission and his family. He would hate to lose his family, yes, but it would be no contest.

"So what will you paint on these buses," I ask. "Do you know yet?"

"I'll know when it's time. I'll read the Bible. It will come to me." He looks at the buses, thinking, looks back at me. "I'm making a record of what I'm seeing. It's no magic vision or anything, just daily inspiration. It seems like I'm not standing still. Things are being revealed to me each day about life and God's plan for the beginning and the end. Not the end of the world but the end of this state of grace when man has a chance to believe and either receive or deny God. People need to be warned. Christian people. Like I said when we talked in Baltimore, in physical form the anti-Christ is the pope. Now there is some indication that you can go one step deeper into the historic seven hills, which I always considered to be in Rome, but you have seven hills in Jerusalem, I now realize. I'm speaking here of prophecy, you understand, of the seven hills, and what could constitute the ultimate anti-Christ may in fact be much bigger than the Catholic Church. The Catholic Church stole the Christian religion, but there is more, I'm finding. That's what these buses will be about, I believe."

We move slowly around the buses: dents, dings, flat tires, the white paint on the side of one sun-blistered, rust-scabbed.

"Religion isn't true anymore," he says. "We have to get back to God. The church has a false image of Christian life, you see; they teach a false image of the Christian way. I hate to say that. It would certainly hurt my brother for me to say that. He is a Christian minister but the church is not Christian. And yes, Bob Jones University [down the road from us] is a great institution,

fundamentalist. They do a lot of good in the world. They train a lot of good preachers. They hold a good standard of morals and everything but they don't know it all. There's a lot, I'm discovering, they don't know or teach. I see it more every day: the real church is not in any particular building. It has pagan steeples. It's in the hearts of the people."

"You think we can meet your brother?" I ask.

"Yes. And my mother, too. I'd like you to meet them both before you go."

We head back to my van. Ahead of us: a shopping center, working-class neighborhoods of one-story ranch homes.

"How are you going to paint these buses?" I ask, rather mundanely, when we get in the van, but I really can't imagine how he will do it short of rigging up some kind of hoist.

I position his crutches between our seats and buckle his seatbelt for him because he is unable, with his shaking hands, to do so.

He pushes up his glasses with his knuckle. "I don't know," he says, as if it's the first time he's thought of it.

18

"My favorite writer is Peggy Noonan," says Jimmy, Thompson's older brother. He looks a good fifteen years younger than Thompson—a big man, tall and heavy, with a head of carefully styled, graying hair. He's wearing an expensive-looking leather jacket, a white button-up shirt, and dark slacks. Several gold rings are on each hand, an elaborate gold watch is on his left wrist, and a thick gold necklace hangs around his neck. He has just built a new church for his large congregation here in Greenville, and he owns a Christian printing press and a local religious cable station. He looks like a heavier version of the evangelist on the hotel television last night. "My favorite thing she's written is the speech for Ronald Reagan after the space shuttle Challenger Crash. Do you remember that?"

"Yeah," I say. "I think she was the one responsible for George H. Bush's 'thousand points of light' and 'a kinder, gentler nation,' too."

"That's right! She's *won*derful." He looks at the ceiling, recites: "'Slipped the surly bonds of earth . . . touched the face of God.' Beautiful, isn't it?"

"Nice."

We're in the living room of the farmhouse where Jimmy and William grew up, which was built by their father. It's a modest two-story house, but nicely renovated and clean. I'm sitting on a soft couch. Thompson—his family calls him "Tommy," which he will later tell me he hates—is beside me. Jimmy is in a chair, smiling and talking about Greenville. Their mother, who is one hundred years old, sits, impeccably dressed and made up, in a wheelchair.

Thompson seems glum. He only smiles when talking to his mother. What a change he's gone through. Twenty years ago, sitting in this room, he was a millionaire, living in an opulent home just across a field from here, probably giving his brother Jimmy advice. Now he's handicapped, unemployed, and, seemingly, the center of family tensions. He's also a lauded outsider artist, though I'm certain his family has little knowledge of outsider art. I imagine what they know of it they find laughable, appalling, or bizarre.

"Watch this," Jimmy says to me.

I watch.

He leans down, his mouth close to his mother's ear. "Momma!" he shouts.

His mother sits in the wheelchair, staring forward, nearly catatonic save for the small smile on her face.

"Momma!"

She keeps staring forward.

"Momma!"

She moves her head slightly. Her lips are the color of overripe cherries.

"See the cows out in the field?" Jimmy smiles at me, winks. There are no cows in the field, and Thompson told me earlier, when he was telling me about how much he hated—he uses that word often—growing up on a farm, that they haven't kept cows

for decades now. "Sure are a lot of cows in the field." Jimmy flashes me another wink.

Mrs. Thompson, after a moment, and in a whisper, says, "There . . . are . . . no . . . cows."

"Can't trick her!" Jimmy shouts, and I almost catapult out of the room. "One hundred years old! Can you believe that? A hundred and you can't trick her. Nothing wrong with her mind. No sir. I don't know if I'd even want to be a hundred! No, I'm not sure I'd want to live that long!" He touches his mother's shoulder and laughs.

Thompson, impatient, speaks up: "Tell him about my art, Jimmy. Can you go on and tell about my art? That's what he's come for. He's a writer who's come a long way to see my art and learn more about my art. Go on and tell him what you think of it. Go on."

Jimmy's face, set thus far at extreme elation, changes, tightens. He purses his lips, considers his response. "Well . . . " He looks at Thompson, at me. "I . . . " Looks at Thompson, at me. "I think he really paints from the heart, you know. That's for sure, Tommy, you really paint with a lot of *feeling* all right."

"You can tell him what you really think."

"That is what I really think. That's exactly what I think."

"Go on and tell him what you really think."

"That *is* what I really think, Tommy."

19

Back in the minivan, Thompson and I head to an exhibit of several of his paintings at North Greenville College, a series of bunkerlike buildings resembling an army base, where art students will, without my requesting it, spell their names for me, where a studio art professor in a red sweater and Birkenstocks will call Thompson "either a mad man or a prophet," where Thompson will tell me, while looking at one of his new paintings of the New York skyline after 9/11, that peace signs are broken crosses, that the hippie movement was all about the devil, that he was almost arrested in Charleston, South Carolina, several years ago for walking into an abortion clinic during a large protest and asking to interview the person in charge, that he and his family always join the anti-abortion demonstrations here in Greenville.

All of this, however, is later. The afternoon spreads out in front of us. The cold, gray road rolls up under the hood. We ride silently. I keep the tape recorder and notebook in my bag.

Ahead and above us a giant billboard showing a manicured Caucasian hand on a rotary phone reads: "JESUS IS COMING FOR A SOUL NEAR YOU." I want to remember that sign: the look of the hand (white and feminine, but not sexy), the phone (black,

from an earlier era in American life and phone technology, a simpler time). The objective correlative of this place.

In stories, there are agents and actions; there are patterns; there is direction; most of all, there is meaning. Even when the consequences are tragic, there is a point; there is a message, a moral, a teaching.

We slow down around some road construction. I think about an Anglo Jesus, a *Y* and *J* conspiracy, the American Visionary Art Museum, Masons, Jews, Catholics, homosexuals, hipster art writers, Thompson's family; how I'm going to make sense of this when I get home to my desk. Janet Malcolm, in her book *The Journalist and the Murderer*, opens with these lines: "Every journalist who is not too stupid or too full of himself to notice what is going on knows that what he does is morally indefensible. He is a kind of confidence man, preying on people's vanity, ignorance or loneliness, gaining their trust and betraying them without remorse." If there is ugliness in outsider art collection, there is ugliness in the collection of a life story, too. No escape from it.

We roll by a group of men in hardhats, each of them holding a shovel and smoking a cigarette, their jeans and arms black-flecked with asphalt.

"I want to tell you something," Thompson says, looking at me. "I want you to understand something: my vision—my passion to paint the message of God—has become my hands, has become my feet, has become my *voice*." He looks out the window again. He says something under his breath. It sounds like, *I'm not crippled.*

Because I am looking at him, and thinking about what he just said, or what I think he just said, I don't see the pothole, and the front of the van bounces and comes down with a hard *thunk*.

I apologize to the side of William's scowling face. "A lot of potholes in this road," I say.

"Yeah," he says. "And you sure are good at hitting them."

THE THIRD NOTEBOOK

Picture-Perfect Jesus

The sentimentality of my documents is a consequence of the fact that I sought them among the extravagances of the subject. If any of you are enemies of what our ancestors used to brand as enthusiasm, and are, nevertheless, still listening to me now, you have probably felt my selection to have been sometimes almost perverse, and have wished I might have stuck to soberer examples. I reply that I took these extremer examples as yielding the profounder information.

WILLIAM JAMES

I believed the night climbed through the window and into my room like a second-story worker. I thought all the night had forsaken the world, and shaped like a fat man, walked through my face and up into my mind. The night had the dirty color of sickness and had no face at all as it strolled in my brain.

JIMMY CANNON

20

There is an abandoned general store in New Franken, Wisconsin, eleven miles outside of Green Bay. It used to be called Greily's. Or Grayly's. Maybe Greenly's. Now that I need to know, that I'm looking for it, that I'm feeling a bit lost inside of my own project, I can't remember.

It's a Thursday in March, snowing. Big, wet, late-winter flakes splat on the windshield of my white compact rental car. I'm wearing a parka and thick gloves, but the cold, this tire-iron-outside-in-January cold, has found my bones, is in my bones.

I lean over the steering wheel. The heater blasts into my face and neck. I'm looking for a diner. I *think* he mentioned a diner. Maybe he said a bar. Our conversations have veered all over the place. My notes, open on the passenger seat, are a jumble about Yesu, crooked art dealers (a Jewish curator in Chicago who won't return his calls; an L.A. dealer who won't ship back several of his paintings), the actual Sabbath being on Saturday (he is very concerned that I put this into anything I write about him), and somewhere, in a thicket of arrows and rural route numbers, how to find him.

Ahead the sky is parking-garage gray and resting on the low-slung telephone wires. The road in the near distance disappears

into the air. Wisconsin is a pencil drawing someone's run moist fingers over.

I've been driving these arrow-straight roads for more than an hour, alongside the flat, geometric fields and dairy farms of the upper Midwest, past a few farmhouses and gas stations, back and forth past the same phallic white silo with a metal tip, the same cold heifers pluming steam from their frost-rimmed nostrils, looking for the home above this elusive and abandoned general store of the painter and sculptor Norbert Kox. An ex-member of the Outlaw biker gang of Waterloo, Iowa, a recovered alcoholic, a born-again Christian, he is now an internationally known outsider artist. He does not, however, receive many visitors, so directions—well, they aren't exactly his thing.

Over the last several months Kox and I have been emailing each other, talking on the phone. I've surfed his website, www.apocalypsehouse.com, Googled him, gone through Lexis Nexis, Expanded Academic, Art Abstracts, et cetera—the basic prejournalistic encounter routine—searching out his name, his work, any mention of him. I have a packet of all the articles and chapters about him and his work. His paintings and sculptures have been exhibited in both well-known and little-known museums in the United States, Australia, Germany, and Great Britain. His paintings have appeared in the New York Outsider Art Fair every year since 1994, and in six of the first eight shows at AVAM. He wrote a cogent essay on Myrtice West, collected in *Wonders to Behold* (though he took offense at Carol Crown's editorial tweaking, without consultation, of some of his writing about theological matters). His art is represented by several places here in the States, including the Tag Gallery in Nashville, and by the famous Henry Boxer in London (who also represents—I find this interesting—Chris Mars, former drummer of one of my all-time favorite rock bands, the Replacements,

whose paintings deal with his experiences growing up with mental illness in his family).

When Kox and I spoke recently, William Thompson had briefed him about our meetings and interviews. We discussed my meetings with Finster's daughter and friends, my visits to museums over the last couple of years, my interest in the visionary experience and the rationales behind the making of Christian outsider art. I mentioned a few magazines I'd written for, the ones he might have heard of, told him about the project, a book contract. An interview sounded fine, he said. He would certainly love to be in a book. "Oh yeah," he said, "a book would be great." He gave me directions and then invited me, quite graciously, to stay with him, though it would be like "camping out" or "roughing it," because he only had one heated room. Thanks, I told him, but I'd get a hotel room in Green Bay, and let him keep at least some of his privacy.

I come to a stretch of five or so homes, pull into the driveway of a brick farmhouse. There is a large, red barn behind it, in considerably better condition than the house, which is weather-worn and gives the impression, as I walk toward it and glance up at a slight concave bow in the snow-covered roof, of sagging.

From somewhere comes the sharp, raving bark of what must be a half-frozen dog.

Several tipped-over green, plastic trashcans under a dilapidated carport; a broken-down Ford pickup in the driveway with a toupee of snow on the cab.

I depress the doorbell, wait a minute. Try again. Hear nothing from the house. Remember an old man chasing me out of his yard with a rake when I was eleven. Whistling, hands in parka pockets. Imagine getting shot with a double-barrel shotgun on this porch, propelled backwards and bloody onto the salted walkway as if in a scene from a Coen brothers movie.

The dog—wherever it is—goes on losing its mind.

Heavy, wet snow lies on the black barren branches of an old oak like skunk stripes. The wind kicks up and flings some in my direction. Clouds flow just above the house.

I'm turning to leave when an old and infirm man materializes out of the inside shadows, sways large and limping toward the door. He's swollen-looking and clearly uncomfortable, face loose and wrinkled as a pug's—type-2 diabetic for starters, I'd guess. He has on a deli-mustard-colored T-shirt and an open brown robe.

He doesn't open the storm door. "Yah?" he says in a flat, tired tone, voice muffled by the smudged plastic between us, the lower parts of which seem to have been licked and wet-nosed by a small, leaping dog.

"Sorry to bother you, sir," I say. "But I'm from out of town and I'm looking for a gentleman named Norbert Kox. He's about sixty, with a white beard." I put my hands on my own beard, as if this clarifies things. "He's a painter. Lives around here. This *is* New Franken, right?" I wave my hand, gesturing toward the several close-together houses, what constitutes a zip code.

"It's New Franken. Yah," he says. Snowflakes on my glasses. Breath fogging and clearing in the air between us. "But I don't know any Robert who paints houses."

"Norbert," I correct. "His name is Norbert. People who know him call him 'Norb,' I think. And he's not a house painter. He paints, you know, pictures, canvases." I'm doing hand things again, drawing squares in the air. "He paints Jesus, actually. He's a religious painter, an artist."

He looks at me, squints. "Don't know him." He steps back to shut the heavy, wooden door.

"How about a general store?" I say, before the door is all the way closed. "Is there an abandoned general store around here? Gray's? Greenly's?"

Inching the door back open, he says: "Greiling's?"

"Right. *Greiling's*"

He points a finger to the left, down the two-lane, double-lined road. It is a road on which cars only occasionally pass, a road for animal carcasses and hitchhikers. The ridges of plowed snow along the gravel shoulders are tan and gray, peppered with black. "That used to be Greiling's," he says. "Closed down a long time ago."

The building he points at, a hundred yards away, is set against a backdrop of mist and snow-covered fields; it's big and brick, with a boarded-up double doorway painted white and large windows crammed with what appears, from here, to be boxes or paper, maybe pieces of plywood. It looks like a warehouse or a loading dock, an old factory. It would be more at home in a rough neighborhood in Brooklyn or Philadelphia than on this frozen prairie, under an ice-spitting sky.

"There is a man over there sometimes," he says. "Older fella. Don't know who he is. Keeps to himself. Don't usually see him in the winter, though. Can't imagine anyone *lives* in that building, young man. But that's it."

21

"Mr. Kox?"

I push a half-open heavy, metal door in the back of the dilapidated building. It has a shiny new deadbolt. Behind me is a mailbox, or a least a kind of metal box one could, if inclined, put mail in. That seems a good sign considering the dead-ends of my morning. As the door squeaks on its hinges—and as I look at nothing but darkness—a hundred bad horror flick scenes flash through my head. This is the part where the music gets incrementally faster and I walk into an abandoned building right here in Ed Gein country.

"Come in, Greg," Kox shouts from nowhere I can see, startling me. "Come in, Greg. Come in, Greg." He keeps saying my name. He sounds excited.

I walk in. My eyes adjust. Above me, peering down, he smiles, greeting me as I walk up wooden stairs, up into a dank storage room. A phrase from Blake's "The Chimney Sweep" floats through my thoughts: " . . . & in soot I sleep."

We sturdily shake hands. "Nice to meet you in person, Mr. Kox," I say. "Thanks for agreeing to talk about your work."

"Nice to meet you, too." He has a deep voice and a thick, slow midwestern accent—Chicago meets Alberta. "Call me Norbert.

Please. Or Norb, if you want." Like "if ya wan." "And I'm flattered that you're interested in writing about me. I just got off the phone with William, actually. He says to tell you hello."

Kox is wearing gray slacks, the cuffs fringed and hanging over his scuffed, brown hiking boots, and a white-and-black checked shirt with several small holes in the sleeves. His gray-white hair is wet and combed back, his white beard trimmed medium-length, thick but not long as in the pictures I've seen of him from his days with the Outlaws.

I get the feeling, from the soapy smell of him, that he dressed up for me. He seems nervous. I have a passing impulse to try to offer up some kind of street cred, a James-Ageeish hand-wringing, tell him that I am no sort of journalist at all, and an English professor mostly by a weird fluke. I want to say that in my early twenties, after my father died and my brother went to prison, after I had ingested enough narcotics and alcohol to make my brain ache like a rotten molar, I figured I would be living just like this, just like him, away from the world and people. I say none of this, of course, since I'm a professional.

Kox lived as a religious hermit for almost a decade in the mid-1970s and '80s in a self-built eight-and-a-half-by-nine-foot truck-bed camper in the North Woods of Wisconsin, past Suring and near Iron Mountain, where he constructed a religious shrine, which he called Gospel Road, devoted to better understanding and explaining the violent crucifixion of Christ. And he told me on the phone that even now he will sometimes go a month or more without seeing anyone (though he seems to spend a lot of time online, our modern, mediated form of communing).

I follow him through the large, dark storage room, past milk crates filled with paint and cleaning solvents, end tables covered in Christmas lights, old newspapers, and boxes. I step past a gold-painted baby doll in a stroller. Scuba gear. A snowboard.

A golf bag. Picture frames, metal wire, old plastic buckets, small crosses and dolls' heads under broken lamps. A chocolate cake-mix box. A dirty mattress, or maybe a box spring, leaning against a wall. Wooden shelves. More boxes. Several more baby dolls and baby doll parts. On this table are several gold chalices and more baby doll heads, an opened pipe wrench. If he is out and sees anything at a garage sale or left by the road to be picked up that he might be able to use in a piece of art, he will pull over and put it in the back of the old Pontiac minivan he now drives, bring it home to be stored for when he needs it, which may be tomorrow or may be never.

"Sorry about the clutter," he says, stepping over a box of dolls' legs. "My living space is just over here."

On one side of the room, over two-by-fours nailed together to form a triangle, hangs a Masonic medallion on a blue and gold ceremonial neck ribbon.

Stepping past a plastic bucket filled with tools, I point to the shiny Masonic symbol. "William had a lot to say about the Masons when I visited him."

"Oh yeah," he says. "William and me—we really are trying to get the message out there about this stuff. You know the Masons are part of the Illuminati, the Illuminated Ones, part of the Luciferian rebellion. Lucifer tried to take over God's kingdom and he's still trying. There are all these secret societies and so-called religions. At the top of all this are the Illuminated Ones. All the presidents of the United States were supposed to be part of the society, and we don't even know who is at the top. Maybe William can tell you more about that. We're doing research, though. The people at the top control everything—all the wars, the economy, the media."

"William seemed to think maybe the pope was the anti-Christ and Hebrew people—he made a point to explain that the real Jews, or God's chosen people, were Anglo—were at the top of

everything." I unlatch my bag. "Do you mind if I record our conversations?"

"Not at all. Go right ahead. The pope, huh? Maybe. I guess that's possible. But he can't even hold his head up, can he? Seems more like a figurehead or pawn to me. I think it goes higher. ~~Much higher. And it's too early to say that it's the Hebrews. It's~~ deep."

He gestures for me to follow him through two wooden doors. "I live in here," he says. He opens the door and let's me go in first.

22

"Somehow I haven't come up with a filing system yet," he laughs. He shuts the door behind us, on which he's fastened a thick piece of pink insulation. We stand in one of his two heated rooms—each about fifteen by fifteen, I'd guess—a makeshift apartment within a storage area. The light is *interior shot, medieval castle, dusk.*

There are more boxes and papers and bric-a-brac so densely packed together that there is only a three-foot wide path through the room. He stands in the kitchen (one side of the room with a sink and counter, a stove, a drawerless white cabinet, an old wok on the stove, pots and pans, a tea kettle, a coffeemaker, mustard, coffee, sugar packets, salt). An American flag hangs down from the ceiling into the middle of the room.

He apologizes again for how difficult it is to get around. On the counter between us: a gold statue of liberty, paper towels, a voodoo-looking doll in a six-inch rocking chair, a black doll wearing a hat, spray paint, a plastic toy cow, a plastic toy mouse, a metal canister of something, spray paint or shellac, American and British flag lapel pins, another baby doll, several scraps of paper, a peanut butter jar.

He's sorry I got lost, too, he says. He should have described the building, given better landmarks.

"No, no," I say, getting out my notebook.

There are large cracks in the sheet rock walls. The ceiling sort of droops, like the top of a tent. A single brown heater, the size of a large, tipped-over refrigerator, blasts and rattles on one side of the room. There is a chair directly beside it, where Kox spends much of his time in the winter reading and studying religious texts. A blue tarp hangs between the two rooms to conserve on heating costs.

"Sometimes I start to file things," he says, looking at the piles of papers and painting supplies and sketches behind me, "but then I get away from it. Can I make you some coffee? I can probably find a cup and clean it out for you."

"No thanks."

"I've gone out and bought all these folders and I plan to start getting all my paperwork together. I have a couple of file cabinets now."

"Looks like you collect things." There is a story about my great, great aunt, how at the end of her life she kept every newspaper and tin can, every broken shoestring and used envelope, until she was almost sealed inside of her home. Walter Benjamin famously wrote that "the collector [has] a very mysterious relationship to ownership." He meant the bourgeois collector, of course, a person like me with my rooms of books, my library to unpack. I believe the poor, the lumpen proletariat, as Benjamin might have called them, collect out of a sense of value based on the very real fear of being without necessities, which is perhaps not so mysterious.

Kox reaches into his old refrigerator, pours some milk into his coffee. "Last fall Davy Damkoehler [the art professor who lives next door and owns this property] helped me out and we

rented a Dumpster," he says. "I just opened up the back door and started throwing things out. I filled the whole Dumpster and then I ended up filling another one after that. I threw out seven tons of raw material." He laughs. "And you can still hardly get through!"

23

Kox, unlike most artists who are consistently considered outsiders, actually left his life as a religious hermit in the North Woods and earned a degree in art from the University of Wisconsin–Green Bay, in the late 1980s. There he met David Damkoehler, who invited him to live here for free after Kox was in danger of becoming homeless for a time in the early '90s, when he could no longer live in his deceased parents' home in Green Bay. Damkoehler teaches courses at UW–GB in sculpture, three-dimensional art, and art theory. At first, back in the mid-1980s, after Kox enrolled in college after receiving a GED, one of the painting professors at UW–GB discouraged him from officially studying art because clearly what he was doing was "authentic outsider art" with religious themes. Finally, after Kox insisted (he had no idea what she was talking about), they allowed him to enroll as an art student, but, according to Kox, they basically let him use their space and do whatever he wanted to do. It is obvious to me, however, having seen his paintings done before and after art school, that he learned a considerable amount at the level of craft, though the tenor and religious messages of his work have not wavered. In fact, if anything, his work moved

further away from the art-historical practice and teaching and the liberalism most people would associate with university culture, particularly departments in the humanities and fine arts. If you were inclined to call his paintings—about the false Christ, about the coming of Armageddon—paranoid, then his paranoia has only deepened and become more intricate and complex over the years.

"I guess I should ask about the acid trip," I say, sitting in one of his two wooden chairs. "Just get that out of the way. I've looked at a few exhibition catalogs and articles about you, and they all mention this bad trip you had before you went out to the woods to live for ten years. Do you mind talking about that?"

"Not at all." He sits down across from me. The heater rattles for a moment. I'm a little fearful of this faint gas smell. Our knees almost touch.

"Do you remember the trip?"

"Oh yeah." He shakes his head. "*Yeah.*"

"What you saw, what you experienced—was it religious?"

"I don't know. Religious? I have something here." He stands up. "I wrote down everything I remembered about the acid trip." He looks around the room while telling me about the trip. A few weeks from now, because he can't find a hard copy in the dishevelment of his home, he will email me the acid trip section of his unpublished, nine-hundred-page book about his religious visions and the coming apocalypse called *Six Nights Till Morning: The Real Star Wars.*

It was the summer of 1974 at a motorcycle hill climb in Wisconsin Rapids; we would always go a day ahead of time and party hard until the hill climb.

I never experimented much with LSD. That night when the acid was being passed out, I was already stoned and overconfident. When I said I would take two hits, my friend wasn't able

to dissuade me, knowing I had never done more than a half-hit before.

Before long, the acid was swimming in my mind, and everything around was either comical or beautiful. Everything that moved had a tail like a comet, and everything that shined had a million sparks. It was blowing my mind. I remember thinking, "Wow! This is fantastic." But the beauty was intermittently shattered by ugly visions and obscene words. The force was closing in on me and I started to feel its effect.

I became trapped in a circle of events, events that always brought me back to the same spot, but each time it would occur I became a little more frightened. Events would happen exactly the same as before. It was not within my power to change one thing, not even the words I would speak. What I saw was an exact recurrence of previous events; the only thing different were my thoughts. I became more and more paranoid each time around.

Vicious dogs were in the air all around, snarling. Everyone was walking through fire, which wasn't unusual for our bunch except for the frequency and order it was happening. My friend Magoo was wearing an underwater snorkling mask. He broke the glass out while it was still on his face. He would laugh hideously, waving a broken-off car antenna, sparks flying in every direction. Fear gripped me deeper as I thought to myself, "I have to talk to someone. I am so scared, I've never been this frightened before." Then another guy I knew, Teen Angel, would jump out of the trunk of his car, and a new spark of hope would lighten my heart as I rushed toward him, then as quickly as he appeared, he was gone. I thought if only I could get some sleep, I might find rest. I knew I could not take much more. I would start to head for the tent, but only a few steps later I would stumble and begin to fall. Then I would find myself staring at the Coleman lantern while the moths would land in the fire and die. Every episode ended at

the Coleman lantern, where it began, and then the horrible sights would begin yet again, and I knew I was in for another lap.

While at the lantern, I would feel a certain temporary relief. I would seem to recompose my senses a little, somehow hoping that it was all over, but still knowing in my mind that the repeating chaos had just begun. Soon the fear would grip deep in my bowels. Was I alive, or dead? There was no way for me to know. I prayed that it was all my imagination and that the gang was just trying to freak me out. But to my dismay I would find myself staring once again at Magoo, seeing him through the shiny glass of the snorkling mask, which would then again twist and break, glass falling down his heavy beard. It's one thing to watch the *Twilight Zone* TV show, it's another thing to live a creepy episode over and over again. I was crying, I was peeing my pants. I thought I would die of fear, but when death didn't come, I thought that I had already died and gone to hell. I'd been through these hell circles four, five, six times, and then they were still going. By now I had almost given up hope thinking that I'd ever see my family again. I was in another world. If I was not dead, I was a zombie locked in an insane asylum.

I wanted to repent. I wanted another chance. "Oh God," I said, "don't let me be like this forever." I do not know how long I prayed, or all that I said, but God did hear me.

The air began to feel different. The ice-cold chill had melted away in the summer breeze. The cases of beer that had been stacked high the last time around were now empty cans and torn cardboard. The perspiration evaporated from my forehead and I began to collect my thoughts. I could not believe it. It was too good to be true. Had hell rejected me, or was Satan just building up for the big one?

"A *very* bad trip," I say after he finishes describing the episode.

"I really thought I was dead or insane," he says. He sits down. "I didn't know any scripture back then, you know. I couldn't make much sense of the experience at the time. It was just really horrible."

Looking down, I notice a swastika tattooed on his hand that he's attempted to cover with another tattoo, a rose. The swastika, however, is clearly visible under the red of the flower, a relic of his biker past. I consider asking him about it, especially after Thompson's anti-Semitic rants and his taking me to the Dixie Outpost, where I was regaled by the most politely delivered racism I've ever encountered, but the engrained bigotry of far-right white Christian culture is so apparent that I'd like to see if we can't get beyond that wall, so instead ask, "Were the Outlaws into drugs?"

"Well, not really. Now lots of gangs are into dealing. But this was before that. There was weed around a lot. Other stuff, too. Speed. Cocaine sometimes. I'm glad there wasn't crack yet! I would have been in big trouble!"

"When did you hook up with the Outlaw Bikers?"

"I got running with them early, when I was eighteen. Maybe seventeen. I was already working on cars and motorcycles back then. I did body work—bondo and painting and some custom car and bike stuff. And I picked up a big Harley. I knew guys who knew guys. That kind of thing."

"Early '60s?"

"Yeah. That's when it started."

"Did you paint back then?"

He gets up, slowly, to get more coffee. He is near-elderly now, gray and calm and steady in his movements, but I've seen pictures of him in his thirties and forties, and some of his realistic self-portraits, and he once looked like a bruiser, leather-clad and thick with both meat and muscle, like one of those professional

wrestlers from the '70s. "Oh yeah, I painted," he says. "I went into the service for a year, in 1962, and a friend there showed me a book with some Salvador Dalis in it, and I tried painting like that for a while. And before that I did a lot of like *MAD* magazine stuff. But even before I started what I think of as my first religious painting, back in 1976, I was thinking about painting a lot, even back in the early '60s, maybe even earlier. I would lie down in bed at night and start dreaming while I was still awake. I could see things. I started putting a tablet beside my bed, I remember. I would lie there and start to see different things, you know. I got to the point where I could stop an image. Then I'd turn on the lights and make a sketch of it."

"The image would stay there, in the air?"

"Well, probably not in the air, but in my mind, you know."

He sits back down in the chair across from me, takes a careful sip of hot coffee.

The heater starts up again. I can see the snow coming down harder through the window behind him.

"Were any of the early paintings religious, before 1976, back when you were a biker and working on cars?"

"I didn't think of them that way at the time. I just thought they were crazy ideas coming into my head. But then years later, after I started to have the spiritual experiences [in the early '70s], I could look back and see that maybe they were religious paintings, you know. They had religious themes. I did these self-portraits and in them I was always going to my destruction. It was God showing me the picture of my life. I was painting what God was showing me. Back before the trip I was already having this feeling of déjà vu that got so bad after I took the two hits of acid. This was maybe in '72 or '73. I would get this weird feeling that I had done this all before. Like I would know you were going to sit a certain way and say a certain thing, and I didn't want you

to, didn't want it to happen, and then you would do it exactly as I had seen it, and I'd be freaked out, you know, terrified."

He tells a story of sitting in his make-shift apartment in the Bull's Eye Body Shop, a small business he and his brother owned in the late '60s and early '70s. He says he knew that one of his biker friends was going to knock on the door. He didn't *want* to know these things, because he thought it probably meant he was losing his mind. Then, he says, the knock came, and there was the friend he knew was going to knock on the door. And the friend said exactly what Kox knew he was going to say. "It got so freaky sometimes that I just had to leave and go out into the woods and be by myself. It was horrible. Really frightening."

"Were you doing acid then?"

"No. I had done it, you know. And I had done some mescaline. I smoked a little dope. But really I was just a big drinker. I loved drinking and I loved to get drunk. I drank all the time. If I drank hard stuff, liquor, I'd black out sometimes."

I once smoked Thai stick with some surfers from Virginia Beach when I was sixteen or seventeen. In the middle of the night I saw my friend's jeep in my driveway. I walked outside. It was only when I went to open the door of the jeep that I realized it was all a hallucination. Back inside, in the light of my bathroom, my face was a hundred years old and bright green. Every inch of me was covered in sores and boils. My eyes looked almost bloody. At the risk of sounding like Nancy Reagan, drugs can have everything to do with tricks in the mind, certainly contribute to them, which is why, once I decided I could maybe live in the world, I never touched them again.

Much like my brother after his first mental breakdowns, Kox started obsessing about religion, about somehow saving himself from these new fears and feelings—reading books about saints and miracles and magic, studying the Bible. He briefly joined a

Rosicrucian sect. He later thought that the Rosicrucians were perhaps Satanists and buried all his religious literature on the topic in a hole in the woods. His life became organized around his spiritual crisis, trying to defeat the evil he felt was pursuing him. His friends, guys from the Outlaw Biker gang and the body shop, began to worry about his mental state.

"I realized at some point that I was feeling the presence of God," he says, setting his coffee cup on the heater and crossing his legs. "It wasn't like an audible voice or anything. It was more like thoughts coming into my head that weren't my thoughts. I knew I was going to be changed, going to become a servant of God. After the first time that I felt God I really wanted to feel His touch again. I would pray and meditate but nothing was happening. Then one day I was driving my truck and talking to God. And I said, 'God, if it never happens again, that's okay. Just that one touch was enough to make me know that I'm going to serve you for the rest of my life.' As soon as I said that I started to feel it again, this amazing power, and tears started pouring down my face."

"Was this before or after the experience at the hill climb?"

"I'm not sure. It was a long time ago. I remember everything, but it's hard to remember what came first and what came second, you know."

"Just before you went out into the woods for ten years?"

"Yeah, like right before that probably."

I ask if he remembers other specific incidents.

"Yeah," he says. "After I bought out my brother's half of the body shop I was living in the camper of my truck in the parking lot. Like 1974 or '75. I was praying and meditating a lot at that point. But see I didn't really want to tell people about what was happening to me. Things were just coming into my head, all these thoughts. And they weren't my thoughts. I had to tell someone so I drove over to my father's house. He was sitting

in his favorite chair in the living room, like he always did, and while I was getting ready to tell him about these things that were happening to me—he was real concerned, you know, leaning forward and listening—I started to feel the presence of God. I mean, really strong. And for a split second I didn't see my dad. Instead I saw Yesu Christ crucified. I could see his flesh bleeding. It was just a split second. I was crying and my hair was standing on end and I had goose bumps. And then after a minute my dad said, 'What's wrong?' I told him and he understood. He didn't judge me or anything. He was a good man. See, I had never seen the crucifixion, how brutal it was. I didn't know how violent the whole scourging was, you know. They tear your flesh and break your bones and torture you. They wouldn't let Christ's body die for a long time." His eyes begin to glisten as he talks. "It came into my head that I needed to paint that picture, what I had seen, a picture of Christ crucified as he really was. I went over to Green Bay Art Supply. I bought a big piece of canvas and I glued it onto Masonite with Elmer's glue because I didn't even know how to stretch a canvas at that point. I really didn't learn how to do that until I went to art school. That was the beginning of my first real religious painting. It's called *Blood Offering: Yesu Christ the Sacrificial Lamb*. When I started painting it, which wasn't long before I went up north to the woods, I had to have a family friend sit with me because I could feel the presence of demons in the room, like they didn't want me to paint it."

At home, weeks ago, looking at several of Kox's paintings on the Internet, including this first one he's just mentioned, I made a note of a recurring set of small, menacing-looking cartoon people, reminiscent of a motif in Adolf Wölfli's illustrations. I think of how Prinzhorn suggested that an ordering and expulsion of psychological menace often found its way into the works of his patients, and one sees this kind of ordering rendered as obsessive motif throughout the history of outsider art, and across cultural

boundaries. I ask, "Are these the demons you have in a lot of your paintings—bald, round head, sloping eyes, dark skin?" (They are a mix of African and East Asian features.)

"Yeah. Those are the one's I saw," he says. "They end up in a lot of my paintings. It's like I'm haunted by them."

In Wölfli's illustrations, I've always thought Wölfli himself, an imprisoned pedophile and schizophrenic, was the menacing face that popped up symmetrically around his ornate, colorful designs. In Kox's first painting—blatant and symbolic, classically Christian and painfully autobiographical—he is the one being taunted by the faces. He is the tortured savior jeered at and ripped to shreds.

24

Later, when Kox excuses himself, I head for the next room, since the bathroom door doesn't close all the way and I can hear the splashing of him relieving himself in the rust-circled toilet bowl. "I'll give you some privacy," I say. I duck under the blue tarp, open a bowed wooden door, its bottom scraping over the gouged and grooved floor.

Here, immediately in front of me, is a recent sculpture, if that's the right word—a six-foot, bearded Statue of Liberty (a plastic figure from a junk shop or costume store) in a devil's mask, with "666" written across her forehead, wearing four bras, one below the next, each with gold nipple tassels. I laugh. I'm pretty sure you're supposed to.

Beside Lady Liberty, leaning against a wall, is a man-sized, wooden crucifix out of which grow bloody baby doll arms, legs, hands, torsos, and heads. Every small body part is painted bright red, as if just pulled from a blood-filled barrel, from the sea at Armageddon. My smile fades. The hair on my arms stands up. I'm squeamish, have no stomach for violence or injury, and feel a rising puke pressure in the back of my throat.

This other part of his living space is the bedroom and computer room. Though he has become well known in the outsider

art world for his colorful, apocalyptic paintings, particularly his Jesus paintings—Jesus in a gas mask; Jesus smoking a pipe; Jesus with devil horns and talons; Jesus in a cop hat—he has done a number of three-dimensional, mixed-media pieces. His sculptures always begin with found objects—anything from mannequins to car grills, baby dolls to old animal bones, bed frames to religious trinkets—and it is clear that his experience and remarkable skills as a custom-car and bike mechanic have not been forgotten.

He walks into the room, putting on an old zip-up ski sweater, blue with geometric mountain designs in white and red across the chest. From a distance of ten feet, before you can see the holes in his sweater, he looks like a middle-class granddad getting ready for a stroll through the park.

"Ah, you found these," he says.

"Yeah. Wow. This baby thing."

I turn and stare again at the dismembered-baby crucifix, which is at once politically simplistic, absurd, and disturbing, not unlike something you might see at a pro-life march. At the top, in the middle of the cross, is written "Land of the Free." Andres Serrano's controversial *Piss Christ* (1989) is tame by comparison, if we're going by Duchamp's anti-art shock-o-meter, while this dead-baby cross is something like Serrano's ideological opposite. It's not far-fetched to imagine Kox putting a crucifix or a Virgin Mary trinket in a jar of urine, though. In a way, much of his work is doing just this. Kox, however—with little art-historical knowledge, no notion of Duchamp or Dubuffett or Warhol, or the take-it-all-in-at-once-and-theorize-about-it-later tendencies of conceptual or pop or minimalist art—wouldn't view this sort of postmodern found-object bluntness as art. I don't think, anyway. To borrow another phrase from Peter Schjeldahl, like Finster and West and Thompson, like most true "outsiders," he qualifies as a "denizen of ahistorical time" (yet only if we're placing

him within an art-history narrative; he is, I think, an easy-to-find point on the graph of Western superstition and apocalyptic thinking, perfectly historical).

I think of the huge painting *Idolatry: The Drugging of the Nations* at the American Visionary Art Museum, William Thompson's aborted babies being eaten by "legs" that became dragonheads. At the same time, I'm reminded of the controversies over Charles Saatchi's so-called Young British Artists collection in the late 1990s—Chris Ofili's elephant-shit-splattered Virgin Mary, Damian Hirst's sawn-in-half shark, Tracy Emin's tent with the names of everyone she had slept with sewn inside: titillating, self-reflexive, mocking. Clever art working hard to exist after the end of art, a lot of which, I should say, I find quite compelling, absurd in the best way, and awe-inspiring. Kox's work is composed entirely outside of the discourses of art culture (even with the art degree), but it is, in many ways, not entirely dissimilar in its end product in terms of provocational intent if not aesthetics, except for the important fact that it is not a theorized, intellectualized reaction to the discourses of art and culture, but rather an honest depiction of his religious and political thought. He's sincere, and he doesn't have to navigate the cerebral maze of his own irony and complicit late-capitalist discomfort to get there. Anyway, it's no wonder outsider art can find such a comfortable place in the postmodern / posteverything moment, even while its collectors and exhibitors often traffic in and promote the high modernist notions of the *savant* and the artist as *tortured soul* and ultimately *transcender*.

"This is pretty shocking," I say. "But I guess that's the point. The political statement. Have you had this crucifix in one of your shows?" I can't imagine a curator in America, certainly one with any foothold in the institutions of art (galleries, magazines and journals, academia), that wouldn't have to do a doublethink before putting this in an art museum.

"No," he says, taking a step back into the cluttered room and looking up at the highest crushed baby head, which looks to have been smashed by a sledgehammer. "I was part of a three-person show in Pittsburgh. I took this one down there but the gallery owner didn't want to risk it. It was too much. I would have been happy to talk about its meaning with viewers, how I'm against abortion, but he didn't want to do that either. He was really against that. He said that might be a problem. I wasn't upset, though, because now I'm not sure it's finished. I don't just want a cross, you know. I've got other stuff. I want to build a big alter for this."

"A dead baby alter?"

"Right," he says. "A dead baby alter."

25

A few hours later, after some touring around Green Bay and lunch, back in the same room, I point to his small cot with a green wool blanket against the wall. It's covered in written-on papers and more books, many dusty and old. A wrong move could also bring a stack of heavy religious books crashing down from above, where they are precariously balanced on makeshift bookshelves. "Is this where you sleep?"

He nods.

"I guess you have to move all these notes and books."

"I just kind of push them to the side and sleep right here." He gestures toward the outer edge of the bed. "I don't sleep that much. I usually work until I need a rest. Then I move a few things and lie down for a while. Lots of nights I never even take my shoes off. When I wake up I'll make some coffee and get back to work."

"Are you working on paintings now, or mostly three-dimensional objects, like this crucifix?"

"Both. Everything. I'll work on something and then put it away and then take it out later, when I have a new idea or some new scriptural guidance for it—sometimes years later. That way I always have something going. And I keep these notes in my

pocket." His shirt pocket is overstuffed with pieces of paper and a small yellow pencil, the kind they used to have in libraries near the index cards. "These are ideas for projects," he says, pulling open the sweater and touching his pocket. "Usually I'll think of something—a basic image—and then I'll start studying scripture to see what I can find. I'll let my Bible study dictate the direction and the ultimate meaning of the painting or sculpture." He looks behind me. His face lights up. "I also make music." He points toward his computer.

On the other side of the room, six or eight feet from his cot, is a computer surrounded by several more stacks of books. Near the computer is an old television and near that is a new stereo, with several speakers stacked up above the computer. Folded-over notes. A Bible. A study guide to the Bible. *HTML 4: A User's Guide.* An old computer mouse. A broken computer chair. A functional computer chair. He sits down.

We look at the computer as it boots up, whizzing and whirring and beeping. As I said, Kox runs his own fairly sophisticated Web site, where you can view his paintings, learn of upcoming shows, and find links to sites about the Illuminati and the Luciferian Conspiracy, as well as to other Christian outsider art and artists. On the site is this disclaimer: "This is not a hate site. It is a site that challenges traditions and exposes falsehoods. This site is not anti-Christ. This site does not present anti-Catholic material. It presents factual information. It exposes counterfeits and dupes in regard to religious and biblical interpretation, whether Catholic, Protestant, Jewish, Moslem, Hindu, Buddhist, Athiest, Satanist, New Age, or any other religion, non-religion, or philosophy."

He picks up several CDs he's made recently. He scans photos of his paintings to use as CD covers. His music alias—his one-man band, if you will—is "Mr. Noah."

"What kind of music are you making?" I ask.

He hands me several of the CDs, with the titles *Divine Overture, Apocalyptic Chaos, Dancing in the Furnace,* and *Babylon is Falling.* "I'll play some for you. If you don't mind. Hold on."

Synthesizer music with a basic rock beat suddenly blast out of the stereo speakers. It reminds me of the music from *The Terminator*—eighties, vaguely sci-fi. I nod my head.

"I'm making music from my paintings," he shouts over the volume. "Scriptural music."

"How do you do that?" I yell back. "You have some special software?"

"Yeah," he shouts. "You know, years ago I didn't know how to use a computer. I just taught myself to use one by reading books and tinkering . . . "

"What?"

" . . . computers! Reading books and tinkering!"

"Right!"

He smiles, drops the volume several clicks.

I now notice several more computer books stacked on the floor, against the wall.

"Anyway," he continues, "what I do is I get a picture of one of my paintings. I scan that picture and this program looks for pixels, different colors. Each color is assigned a different note. I have a couple of different programs that will do this. Then you can take the notes and play them on different instruments—horns, guitars, harps, pianos. You can layer tracks, do a bunch of stuff. And I have this other program, too." He holds up a software CD case. "*This* is interesting. See, all of my paintings have to do with Bible verses. So I'll take the verses I've used for the painting or written on the painting, or sometimes I'll do a whole chapter from the Bible that's inspired a painting, and then I'll get the Hebrew version of the verse. Because I can change each Hebrew letter into a musical note with this software, see.

So I'll turn my paintings and even the scripture I used in the paintings into songs. You don't really know what you're going to get, but once you get the basic song, you can mess with it and change it until you get something you like. Once I do that I burn a CD. I want to start bringing them to my art shows. I have a show coming up at the America Oh Yes! Gallery in Washington, D.C. It's called Picture Perfect Jesus: The Glamorous Fraud. It's my series of Warner Sallman Christ Head paintings. I might see if they'll try to sell some of my music. I don't know if they will, but I might see."

He turns up the music again. *Chariots of Fire* meets Metallica, or, more specifically, a crunching speed-metal beat and what sounds like growling straight out of some B-movie notion of "hellish" mixed with high-affect classical sounds in what I'd have to call a Muzak vein.

"Be honest," he shouts. "You're a professor. You're a critic. What do you think? I can take it."

"I like the idea," I yell. "I love the intricacy of your methods."

"Thanks!"

26

The big, brown heater kicks on. I'm shivering. Still this faint smell of gas, but I try to ignore it, since Kox insists it's nothing. We're back sitting in the two chairs in the other room, discussing the mission of his art. Outside, three more inches of snow have fallen.

"Would you call it a crusade, this way you and William Thompson are calling attention to what you see as the false scriptures and rituals of the church in your art?"

"Crusade?" He thinks. "I don't know about that. I don't like that word because it has a lot of negative meaning, historically. I think we've just discovered something, something dangerous for believers, and we're trying to expose the truth."

"How?"

"Much of the Bible," he says, after a moment, "has been mistranslated on accident, I think. But a lot of it has been intentionally mistranslated to support the doctrines of the church and to keep the powers that be *in* power. To start exposing all the false things in scripture will overturn everything. People controlling things don't want the truth to ever get out."

"What you're saying, what your paintings are saying, would be terribly upsetting for a lot of Christians," I say. "And I'm

thinking of fundamentalists, people who spend a lot of their time praying and in church." I put the notebook down. "Well, like William Thompson's situation. When I was down there I sensed a lot of tension in his family because of what he was doing up in his studio."

"Oh yeah. When I painted *Idolatry* with William we did it down there, you know. One day his family confronted him there in the kitchen. His daughter and son-in-law just said a lot of really hateful things to him, that he was crazy and all this, that he needed to be locked up. It really hurt William. They don't respect him." He shakes his head. "They kind of treat him like a freak. And they thought I was still a biker and all, too. I remember people were really upset in the kitchen—his daughter was crying, his son-in-law was saying a lot mean stuff. It got pretty out-of-hand. Eventually everything calmed down and his wife, who is really a very kind person, said I was welcome to stay, but for a while it was tough going."

"The whole mission of your work," I point out, "criticizes their way of thinking and believing and worshipping and maybe even living. I mean, you paint their idea of Jesus with a pig's nose, or devil horns. I can imagine that they might even think William has been taken over by the devil—with all the darkness of his paintings, and how he keeps questioning religious teachings in his journals and even in just the things he says."

"Yeah," Kox says. "Sure. It's hard to get people to open their eyes. The righteous path is narrow. You want people to come to it, but you can't make them."

Kox himself was married back in his biker days, though he and his wife were "on-again, off-again." He has a son about my age, born in the early 1970s. Most of his life, however, especially since the mid-1970s when he began to have his religious visions, has been spent alone. He and his son, who lives in Green Bay, do communicate fairly regularly and, according to Kox, have a

good relationship. A picture of his son at the age of four or five, kneeling down in sunlight and feeding a pensive duck, hangs on the wall above his cot. I looked closely at the picture earlier, because of how out of place it was in relation to the rest of the room. It's an image of a happy little boy smiling in a park somewhere in the past. It looks spontaneous in a posed way. In the shattered religious chaos of this room it's *precious*, like a postcard. I think of my own small son and baby daughter, holding them, smelling their ears and hair and breath, how sometimes it feels like the one truly valuable thing I do in my life is take care of them. I wonder what he feels when he looks at this picture, if it ever makes him reassess the past, his memories, life. If it makes him sad. If he feels he has had any choice in these matters. "It would be hard to do what you do," I say, "to be devoted to working all the time, and have people in your life, I guess. I mean close relationships."

"Oh I couldn't do it," he says. "It wouldn't be fair for me to be really close with anybody. Like a girlfriend or something." He looks around the room, at the books and papers, the crosses and trinkets he might one day need to use in one of his paintings or sculptures. "Not with the way that I live." He half-smiles, but it's not a pleased or happy smile. "Who would want to live like this?"

27

Kox's paintings are cartoonish. One can immediately see, in the bright colors and caricaturish depictions of biblical characters and demons, the tone and influence of *MAD* magazine, that glib and subversive side of pop culture.

Last night, at the Holiday Inn in Green Bay—have I mentioned how I feel about hotels?—I looked at a picture of one of Kox's works. It was in an advertisement for a solo show he had back in the late 1990s at the Ann Nathan Gallery in Chicago, a city with several good outsider art venues, including Intuit and the Carl Hammer Gallery. The painting was called *Secret Babylon*, and as I stared at it for several minutes, reading the text, looking at a depiction of the Warner Sallman Christ posed as the Statue of Liberty (these core symbols show up over and over), I couldn't get over the darkness of it, the fear and dementia it contained. I stared at the devil feet of Jesus—or rather the false, deceiving image of Jesus, as Kox would point out, and then at the banner announcing the "death of the new world order," then at the little demon at the bottom of the painting (round head, dark skin, slanting eyes—the ones that haunt him), then at the fire in the sky, the mushroom clouds, the Masonic eye symbol from the dollar bill, an American and a British flag. It was fear

and anxiety and suffering, the mind spinning in its tracks, turned into a painting.

I'm thinking of *Secret Babylon* as I drive out to the abandoned general store. Kox and I are planning a tour through a simple gallery for his work that Professor David Damkoehler and his wife, a graphic artist, have helped him set up in the downstairs of Greiling's.

Yesterday, before heading to the hotel, I stopped in to talk to Damkoehler at his home, a gutted and remodeled post office (he bought the abandoned store and post office at the same time). He lives in a functional work of art, with suspended, spiral stairs made of metal leading up to a loft like something only seen, at least by me, in architectural magazines, or maybe liquor ads in the *New Yorker*. A handyman was installing a specially ordered nurse's station sink and a steel prison toilet in his downstairs bathroom. Damkoehler is an artist who works with steel, making teapots and kitchen fixtures that sell for up to several thousands of dollars per piece. He is a heavy-set gentleman who wears hand-made stainless steel spectacles. He has cropped white hair and a beard. Last evening he wore all black and had a silver stud in his left ear and looked like an actor playing the part of a studio art professor. He was polite and immediately likeable, the sort of person—artist, intellectual, academic—that I spend a lot of time around nowadays, and our conversation ranged from car culture and punk rock to how postmodern cultural theory had changed and maybe limited the possibilities of art (though limits weren't necessarily bad). Other things came up: celebrity, the American aesthetic of the hit and the next-big-thing, the comeback of painting, Cy Twombly, Jasper Johns, Sigmar Polke. We liked a lot of the same painters.

For my project I was mainly interested, I told him, in the social and psychological situation out of which Christian visionary art came. I didn't want to be a critic; more like a documentarian. My

idea was to talk to the artists themselves about their intentions. He said that was the way to go. Avoid the tenure-seeking art talk. I told him I was kind of a skill and craft guy myself, in a lot of ways, an "aesthete," sort of, if I could get away with that term while talking to an art theorist without sounding politically naive, and I had arrived here, in Wisconsin, in his home, via an interest in psychology and Christian culture as much as art.

We talked about Hans Prinzhorn's idea of "schizophrenic artists" back in the 1920s. He knew all about Prinzhorn, Dubuffet, Cardinal, Manley, MacGregor—more than I do, in fact—and talked for several minutes about a course in the cultural history of outsider art that he teaches. I then mentioned Thompson, whom he knows, and the art writer at AVAM, and how I thought she was well-meaning, but that there seemed to be a lot of distortion and denial around this kind of so-called visionary work, particularly the overtly religious artists like Finster and West and Thompson and Kox. We bandied about the idea that perhaps this came from a mix of misguided political correctness, governing ideas of the fringes being "cool" and "free" no matter what, and the fact that art institutions—businesses after all—need to cater to patrons while not repelling them or seeming to sanction some of the unsavory political messages that one could read in some outsider work.

Damkoehler said Kox, whom he calls Norb and considers a good friend, has a "radical predisposition to defacing the difference, as Rauschenberg put it, between art and life."

Now, downstairs with Kox in what was once the general store proper, I'm again surprised—moved, actually—by the generosity of Damkoehler, who said taking Kox in was "nothing." This space is large and dark and packed with building materials and

art supplies. Unlike Kox's apartment, however, it is neat, moderately clean, except for some cobwebs and dust in the cold corners. Damkoehler and his wife have expensive bikes leaning against some shelves. There are pieces of metal and metal working tools around, large rolls of paper, canvases, and framing pieces.

"Davy's been real good to me," Kox says as we walk down an aisle that was years ago probably lined with soup cans, pickles, condiments. I've been asking him about his perspective on their relationship. It seems likely to me that Kox would be homeless, or living back in the woods in the camper, without Damkoehler.

We get to the end of the aisle, to a dark opening beyond which I can't see.

"Damkoehler considers you a real friend," I say.

"Yeah, we are friends," he says. "I consider Davy one of my very best friends, even though sometimes I get busy with things and don't see him for a while. I lose track of time. But then I'll remember Davy and give him a call or walk over and see him."

Kox clicks on the lights, which crackle and blink and buzz for a moment before staying on and settling to a hum.

Through this doorway is a large, open room. On every wall is one of his large paintings—as tall as a tall man, and most are about as wide as a double doorway.

I walk in.

There is a large metal sculpture resembling an animal skeleton against one wall. I look more closely. I have never seen anything quite like it. The head of the beast is an actual calf skull. The rest of the body is welded, bent metal, rusted and brown. There is a rib cage and an eerily realistic rusty metal spine. On the animal's back, perched on something like a saddle, is a two-foot icon of the Virgin Mary, a bit of Catholic kitsch. Except Mary has gold devil horns and is riding the beast, which has a dangling, corroded cross hanging from its mouth.

When Kox had a one-man show at the Neville Museum in Green Bay several years ago, a local Catholic leader, a man named Buldoc, called for a boycott of the show and for it to immediately be taken down. There were editorials in the paper, both for and against Kox and the Neville's right to show this sort of art, which is, of course, a *savage* critique of the institutions of religion and especially Catholicism; yet it's intricacy of intent and aspects of "private theatre" make it easily readable, at first and second and even third glance, as a savage critique of Jesus, Mary, and Christians in general.

You could mistake it for the work of a Satanist, a prop for a heavy metal stage show. I mention this to Kox.

He says he has no greater love and devotion than to Yesu Christ. And in his eyes the mother of Christ, Mary, is blessed, though not an idol to be worshipped, as in the Catholic Church.

We walk around—looking, talking. There is a slight echo.

He was, he says, totally misunderstood by the protesters at the Neville, and a little shocked by the whole debacle. The Catholic League got involved. Small groups of Catholics actually picketed the museum—"with signs and everything"—for months. It was all over the local news. Kox, quiet and polite in social situations, mostly kept to his two heated rooms and let the storm go on around him. Yet he says he was hurt by the whole thing. The Neville contacted the ACLU, which defended Kox's right to make the art and the Neville's right to show it (Jerry Falwell, whom my wife and I once saw eating at a Texas Roadhouse restaurant in Virginia, once referred to the ACLU as the "American Communist Lawyers Union," and I'd guess that Kox would have a similar view of them, if he considered them at all, though he did appreciate their support in the midst of the controversy). When the show was finally over, both Kox and the Neville were, to say the least, relieved.

"It's nice that you have this space," I say.

"I don't know what I'd do with all my stuff if I didn't."

"Seems like you have at least a large house full of...you know."

"Junk."

"Art supplies."

"Oh, I probably got three large houses full of stuff, even after throwing so much out!" says Kox, smiling.

I walk around the room, one light still flashing like a ministrobe above us, giving the place the feel of a dance hall in an Eastern European mental ward.

Here, against some exposed yellow insulation, is a depiction of the crucifixion of Jesus, one of the most painted tableaus in Western art. This version, however—Kox has many versions—has Christ "as he would have looked after the scourging."

"I painted my first Christ painting without the wounds," he says, "but I knew it wasn't finished. I just had this feeling, you know, that Christ wasn't quite right. That was when I started to really study up on crucifixions and scourgings. I wanted to paint it like it would have been."

I step back, take in the whole of the painting. Jesus, as a cartoon, is literally mutilated on the cross, with giant bloody gouges taken out of every part of his skin. Each wound has meat—a flap of flesh—hanging from it. Jesus' nose is swollen and broken, crushed as if someone hit it with a car, and his cheeks are as puffed as Marlon Brando's in *The Godfather*. Blood runs down Christ's arms from the nails in his wrist, down his face from the crown of thorns, down the cross from his broken, ripped, nailed-down feet. Around him are three women, Mary, Mary Magdalene, and another anonymous woman. In the background are the demon faces again—round, brown, and slant-eyed.

We move on.

The paintings, at the level of craft, did improve significantly during and after his art education, though I imagine someone like Schjeldahl, with his critical eye, would consider all this the work of an unstable amateur. Clearly Kox's thinking and his idiosyncratic study of scripture also became more complex in how they found their ways into the paintings over the years. The work, after that early crucifixion scene (started in 1976, and by far the simplest in color and characters), slowly became busier with symbol and bright and maniacal in a way that makes them more interesting as both art and conspiracy theory.

"This is one of the Sallman series I did," Kox says. He stands in front of a large canvas on which Christ in a Superman suit is having the back of his skull blown off by a little light-bulb-headed man with a sling-shot. Blood and smoke leave the back of Jesus' head and the smoke, as it moves away from the skull and spreads, becomes writhing, bloody snakes descending from . . . what? . . . the evil brain-matter cloud, I guess.

I smile at how punky and deranged it seems at first viewing. There is, I think, a lot of intentional humor in Kox's work, and perhaps even a sadistic streak, a reveling in the possibility of cheap shock.

"Lots of people think that I'm anti-Christian when they first see something of mine," says Kox. "And I'm real sad about that. I really am. But I have to make what I'm supposed to make. See, my work, the way things are going to end up, becomes clear to me as I go. It might change a little, but the basic design just comes to me. I have to follow that. Lots of times, like at a show I had at Lehigh University, where they study outsider art, I will have explanations of my paintings for the public to read. That seems to help. A few years ago, though, at *The End Is Near* book party in New York City—that's where I met William—I had this very painting up with no explanations at all because it was just a

one-day show, you know. I saw across the room that this great big guy and this other little guy were pointing at the painting and starting to get loud and kind of angry. I walked over and tried to talk to the big guy about my work and when he understood that I had painted it he started screaming at me. 'You had no right to do this!' he shouted. He was going crazy, slobbering. But then I told him that this was a picture of the false Christ, the anti-Christ, and that the true Christ was this light here with the slingshot destroying the false prophet. After a while he calmed down. But for a minute there I thought I was going to have to fight and I didn't want to, you know. I haven't fought since I was a biker, since I used to get the stuff beaten out of me by the cops. I never want to fight again. But those who try to preach the true word of God will have it tough. It says that in the Bible."

"That's funny," I say. "William said something very similar to me when we talked about the tension and controversy some of his work has stirred up."

"William's a true Christian," says Kox. "Christians have always been persecuted. He ought to know."

28

"Name's Robert. R-O-B-E-R-T."

"Okay," I say, dutifully holding my open notebook. "So Robert, then, spelled like Robert. Got it. Thanks."

Kox and I have just arrived in the machine shop in the art department at the university.

This place is a high-ceilinged room filled with table saws, large drills, and other kinds of massive cutting, fastening, and shaping equipment. It reminds me of a shop classroom at a large public high school. Several paintings, mixed media projects, and sculptures hang from the highest parts of the walls, just below metal rafters. The lights are squint-inducing bright, and we all look a little whiter than we are.

We're talking to Robert R.—or rather he is talking to us. He's an adjunct instructor who came out of the corner office when we walked in. He teaches sections of tool safety, a required course for all studio art majors, and is, I'd guess, in his mid-fifties, balding and gray, with brown, horned-rim glasses and an unruly ZZ-Top beard. He's about six feet tall, between three hundred and three hundred and fifty pounds, slightly narrower than his office doorway. He's wearing stained gray chinos, a red-checked flannel shirt, and black nondescript shoes. When we shook hands

in greeting a minute ago he squeezed my hand almost impolitely hard, and I'm still wiggling my fingers about it. His voice is loud, and around him, I notice, Kox becomes something of a wallflower, speaking only when addressed.

As I look around at some of the students' drawings and paintings and sculpture fragments, Robert asks me, "How old are you."

"Thirty-four."

"See, you just haven't experienced enough at thirty-four. I don't think you can write a real book at thirty-four. Hang around here. Hang around me and Norb. I'm telling you—it's gets *wiggy*."

"Wiggy?"

"*Wiggy*. Like will *freak you out*."

I write the word "wiggy" in my notebook beside R-O-B-E-R-T and this: ☺.

"Tell him, Norb," Robert says. Kox smirks, shakes his head. "Tell him how it is around here. Oh go on."

Robert walks toward me and leans against one of the bolted-down, wooden tables, which creaks under his weight. "So you're interviewing Norb?" he says. "You should interview me then. I can tell you all about him, although he might not like everything I say about him. I like some of Norb's pieces. *If* they're positive. Actually I should say I *respect* Norb's art but I don't *like* it. When Norb walks in and sees some of Mike's art he walks right by it. When Mike walks in he doesn't like Norb's art. I give them both a hard time. We argue. Other than that we all get along. We're like the three musketeers." He laughs, loudly.

"Who's Mike?" I ask.

"You didn't tell him about Mike, Norb?" Kox shakes his head. "Oh you gotta tell him about Mike, man!"

"Mike Chipokovich," Kox says. "He studied here, too, and he still hangs around." Kox has not mentioned any of his friends

except David Damkoehler and William Thomas Thompson, but Robert and Kox, after some thinking out loud, agree that the three of them, Robert, Norbert, and Mike, have known each since just after Kox came to school here full-time.

"Oh," Robert says, "now if you want someone to write about... If you want to like *discover* someone... Oh my Lord! This could make your career. You'll like sell a million books. Mike does Mother Theresa, Marilyn Monroe, and Shirley Temple. That's sort of like his religious iconography. His work is amazing, totally realistic, like a photograph. But see he's into beauty and innocence and that's why he don't like all of Norb's dark stuff about hell and Satan and the false image of Yesu. Everybody's on the road to hell with Norb here."

"Yeah," Kox says. "And Mike's work is good—he's a talented guy—but it's not *saying* anything that I can see. Just pretty."

"See what I mean," Robert says. "It's like this all the time. Bickering back and forth. But we love each other anyway." Loud laugh. "Hold on—what's your name—Gary?—Greg?—hold on, Greg."

I make a note about Joseph Cornell, his intriguing boxes, how he, too, was obsessed with Marilyn Monroe, his correspondence with Duchamp about art and women and loneliness, then I stop because I realize none of this has anything to do with the present moment.

Robert rummages around in his small, cluttered office in the corner of the room and then comes back with a pencil drawing of Marilyn Monroe, which is clearly the work of a remarkably skilled drawer, and a black and white photo of Mike, which is a head shot, but taken from below, to give it a slightly arty air (I assume one of the other art students took it, art students often being overly attracted to curious photographic angles). Mike looks—I'm going to be blunt and a little cold here—stereotypically retarded or mentally ill. He is dangerously thin,

all jutty bones and pale skin, with the wispy and patchy beard of a teenager who has somehow lived to be in his late forties without ever using a razor. Mike, from the look of it, also cuts his hair, which is chopped into extremely different lengths, from almost buzzed to four- or five-inch long strands.

"You gotta see how Mike paints," Robert says. I hand the photo back to him. "He paints horizontally by putting down a canvas in the attic of the place where he lives. He straps himself up in these harnesses." He gestures with both hands over his shoulders, between his legs.

"Yeah," Kox says, "he's an interesting guy. He fixes his own shoes with old pieces of tire rubber. Wears the same cheap pair of shoes for a decade. And he walks everywhere, like twenty, twenty-five miles a day. So in the winter, when it's twenty below, he has this suit made of bicycle tire inner tubes. He puts that on and walks here wearing a snorkel and a diving mask." Kox smiles. "He runs the snorkle through the inner-tube suit so it heats up the air he breathes. He swears that it works, that he breathes nice, warm air the whole way. He does look warm when he finally shows up."

I'm scribbling away.

"Oh yeah," Robert says. "Mike is interesting, all right. He is something. But a wonderful guy. Gentle as a butterfly." Without pausing he asks, "So who else are you interviewing, anyway? Who's in your book?"

I tell him of my trips and interviews.

"So you're writing about outsider artists who are religious nuts then?" Robert says. "The nutty religious painters book!" He laughs. "There's your title!"

Kox smiles, but in an I'm-embarrassed-that-Robert-is-like-this kind of way.

"I wouldn't put it that way," I say.

"How would you put it?" he says.

I can tell that in all conversations he likes to position himself like this. He's literally and figuratively talking down to me. He's the kind of person I usually spend about fifteen seconds talking to, but now I'm out to "get a story," as Beverly Finster put it, so I forge ahead, lay out a few of my ideas.

"Man, that sounds *boring*," Robert says. "What kind of book is that going be?"

I shrug.

"So *detached*. So *dispassionate*."

"I don't know. Could be passionate. If I'm passionate."

"Are you passionate? Are *you* a religious nut?" Robert asks.

"A religious nut?"

"Yeah," he says. "You're writing about Christian artists. Why?"

I give him my Cliff Notes autobiography—the South, Christianity, a little family history while avoiding specifics.

"Are you just an observer?" Robert says.

"Well, I'm an academic."

"An *academic!*" He makes a sarcastically impressed face.

"Well, a writer in academia. An obscure writer and a fake academic is maybe more accurate."

"Well don't miss out on this."

"On what?"

"This." He holds up his hands, palms toward the ceiling. "A life with God is a special life, young man. Don't be detached. You know Norb and I, we pray and study together sometimes. If you ever wanted to pray with us, we'd be happy to have you."

"Thanks for the offer," I say.

Kox suddenly seems ready to leave. It's hard to gauge his relationship with Robert, and he is not one to try to articulate the nuances of a friendship.

Robert then tells the long story of his own religious travails. It seems that over the last few years he has become a preacher at

his church. However, as he and Kox studied the Bible together, Robert began to pick up on some of Kox's theories about the Bible itself being a false text—something like the word of God filled with the devil's tricks. So Robert began to try to interpret the *real* word of God from among nefarious biblical falsehoods. He told his packed fundamentalist congregation that they—like Kox and Thompson—should call Jesus "Yesu," for that is the Son of God's real name. He later told them, after closely studying some text with Kox and then on his own, that all women need to cover their heads and keep them covered so as not to offend God. He then told them that all men should stop shaving. He has gone from jovial to deadly serious by the end of his story, because, I gather, he is on the verge of being kicked out of his church, which is, I think, his community, his identity, his life.

"Let me just say one final thing to you, Gary," he says. His mouth is in a frown. "*Don't* commit suicide."

I feel like he just smacked me in the face with one of his giant hands. "*What?*"

"Don't kill yourself."

"I heard you," I say, "but I'm confused as to *why* you would say that. We don't even know each other."

Robert looks at me, at Kox, at me again. "God's been talking to me," he says. "He's told me a lot of things lately. He told me to grow this beard." He touches his beard. "He told me that my wife should wear a bonnet because that's what it says for women to do in the Bible. It says that plain as day, Gary—I could show you where. And he told me that people all over the world in the last days, especially young people like you, will begin killing themselves because of despair."

29

In the car, on the gray way back to Kox's two rooms above the store, heat blasting out of the rectangular black vents, I mention how I've noticed that he makes it clear when we're talking that he *feels the presence* of God.

I'm thinking about the *presence* of God versus the *voice* of God. I wonder if he's ever *heard* God, or other voices, the way my brother did, the way several of Prinzhorn's "schizophrenic artists" did.

"No," he says. "I think if you're hearing God you need to be careful."

"Why?"

"Because you have to be careful about whose voice you're actually hearing."

"The devil?"

"Yeah. Or demons."

"Robert talked about having conversations with God. That seemed very literal-minded to me. He believes God is *speaking* to him."

"Oh, Robert." He shakes his head. "He's had a lot of problems over the years. After his first wife left him I was thinking he might do something drastic. He was pretty bad off. After that,

he got real religious. He says a lot. He's a good guy, you know, he's my friend, but he talks all the time and can get carried away."

"You were bad off, too, right?" I say. "I mean before you left to go live in the North Woods by yourself for all those years and set up Gospel Road."

"Sure," he says without any hesitation. "Some people thought I was going to kill myself, I guess. But I wasn't depressed. I was coming out of a depression. I was coming out of a sickness. My life, everything I was doing for so many years, was sort of a sickness. My faith was a cure. I had a message from God—a very clear message—to give away everything I owned and to go up into the woods and live like a hermit, spend my time studying and making art. I was *finally* doing what God wanted me to do after a life lived the wrong way."

In the North Woods, Kox made a crucified Christ out of a department store mannequin, car bondo, red paint, and wood. He made historically accurate scourging instruments—a crown of thorns, whips, skin rakes—and placed them in a display box. He cut a path through the woods and posted biblical quotes about the crucifixion to trees, made it so visitors could take a tour of Christ's brutalized last moments, though only a few visitors came over the course of the decade. He tried to put up a sign but the county tore it down almost immediately—something about a permit. Mostly he was alone out there—hours and days and weeks and months and years. Kox called Gospel Road, which no longer exists, a shrine, and he considered himself an aspiring scholar and tour guide. Professor Damkoehler referred to Gospel Road as Kox's first art installation.

"So you felt confident in your decision to get rid of everything and be away from people?" I ask.

He *had* to get away, he says. He was sick of drugs and drinking and the biker life, sick of the cops coming after him and sick of spending time in jail. Sick of blacking out. Sick of fighting and

getting beaten up. He remembers being handcuffed and a cop kicking him down a flight of wooden stairs. Blood everywhere. A guy came to his parents' house with a gun. He had to jump from a second-story window. Man, it was a crazy, he says. *Crazy.* He had to get away from that life. He wanted to live his life peacefully, to shed his dark and confusing and painful past and have some purpose for being alive, some reason for being alive. He had a "real good feeling," he says, about leaving, about getting rid of almost everything and going away, disappearing. "In a way it *was* like suicide," he says. "The old man died and the new man was born." And Gospel Road, painting, all of his art—they became a way for him to devote himself to God, to his idea of God, to teach the truth of prophecy as he has come to understand it over these years in the woods and in an abandoned general store, while writing a nine-hundred-page spiritual autobiography and producing hundreds and hundreds of works of art.

As for me, I'm starting to feel scuffed and beaten by all these stories, all this pain, even though I asked for it, traveled around looking for it.

But maybe before I drop Kox off, just for the sake of conversation, to let him know something of my own life, I'll arrange my facts into the shape of a visionary art narrative, since I've come to think that that is what we all must do, ultimately, keep shuffling our facts until we find an arrangement with which we can live, until these fragile facts form a straight line toward meaning we then hold onto (whether we are conscious of it or not) like a life rope. I'll tell Kox that I was troubled once, too, had a creeping sense of pointlessness scale and cling tight to me like a vine. But I was reborn, am now bone and flesh and heart and mind in the world because of the beautiful light of grace I feel sometimes when I concentrate and devote myself to making things, to getting the stuff inside of me, the problematic stuff inside of me, into a form I can set free.

Instead I look out at the distance as we float across the frozen prairie, in solitude and quiet that only occurs in rural winter. I have a plane to catch, a home and a family to get back to. I have notebooks, tapes, memory. As if on cue, and almost ridiculously, snow like ash starts falling from heaven.

ACKNOWLEDGMENTS

Thanks foremost to the artists and their friends and family members who appear in this book. I tried to take care to portray our conversations and interactions, which took place between late 2001 and early 2004, as accurately as my memory would allow with the help of tapes and transcripts (which were remarkably helpful). But a narrative is not life, and a moment in a text is not a moment, only a made thing that presents the illusion of a moment. I did my best, though, to make these illusions look and feel like life, at least as I experienced it; and then, perhaps like a documentary filmmaker, I tried to string together and juxtapose some of what seemed to me to be the most meaningful moments in a way that made sense and told the story as I saw it. I don't think I have ever been so conscious of trying to avoid distortions, mystifications, and hypocrisy as I have been in this project. I hope especially that I have been fair.

Thanks also to the many people I talked to, and tape recorded, who do not appear in this book. You know who you are. To extend the documentary filmmaker simile—whole *reels* ended up on the cutting-room floor. If I were a different kind of writer—a Joyce's *Ulysses* kind instead of a Camus' *The Stranger* kind, if you

know what I mean—this thing could have swelled to four or five hundred pages.

Thanks to Susan Bielstein, Anthony Burton, and Mara Naselli at the University of Chicago Press for support and help along the way. It has been a pleasure to work with people who do not think of books as a commodity for sale in the marketplace before they think of them as ideas, language, stories, and attempts to make sense of some part of our world.

Thanks also to the University of Vermont's College of Arts and Sciences for the Faculty Research Grant that helped to defray some of the cost of this book. Thanks to Robyn Warhol for the push.

Thanks to the editors of *The Oxford American*, where an early and abridged version of "The First Notebook: Visions from Paradise" appeared under the title "Visions of Finster" in issue 44, March/April 2003.

Finally, as a writer of essays and short stories, as an *amateur*, I am never, not even on Halloween, an art scholar, art theorist, cultural anthropologist, sociologist, or ethnographer. Many days I'm simply the guy cutting the lawn or changing diapers. This book, then, is my willfully subjective presentation of a sliver of a sliver of the world of outsider art, the one that happened to be closest to home for me. For their valuable ideas and contributions to the scholarship and cultural and art history of the field, without which I would have had no idea how to situate, in my own mind, this foregrounded travel narrative, I thank Roger Cardinal, Leo Navratil, John MacGregor, Michel Thévoz, Colin Rhodes, John Maizels, Lucienne Peiry, Bettina Brand-Claussen, Inge Jadi, Caroline Douglas, Roger Manley, Robert Peacock, John Turner, Gary Alan Fine, Carol Crown, and Tom Patterson. Outside of outsider art, the ideas of Arthur Danto, Robert Hughes, Allen Kaprow, Bill Beckley, Mike Kelly, Dave Hickey, Calvin Tompkins, Peter Schjeldahl, and Johanna Drucker were much in my mind.